IMAGES
of America

PEMBROKE

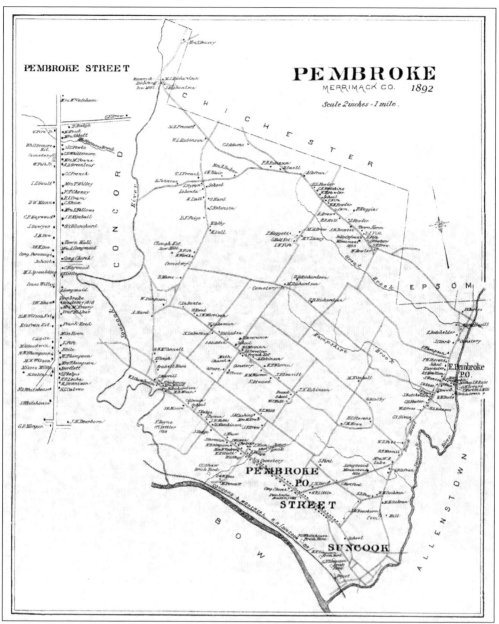

MAP OF PEMBROKE, 1892. This map was taken from *Atlas of New Hampshire*, compiled by D. H. and Company in Boston, Massachusetts. This source is popular with genealogists because each house is identified with the name of its owner. (From the collection of the author.)

IMAGES
of America

PEMBROKE

Lianne E. H. Keary

ARCADIA

Published by Arcadia Publishing,
Charleston SC, Chicago IL, Portsmouth NH, San Francisco CA

Printed in Great Britain

Library of Congress Catalog Card Number: 2004115878

For all general information, contact Arcadia Publishing:
Telephone 843-853-2070
Fax 843-853-0044
E-mail sales@arcadiapublishing.com
For customer service and orders:
Toll-free 1-888-313-2665

Visit us on the Internet at www.arcadiapublishing.com

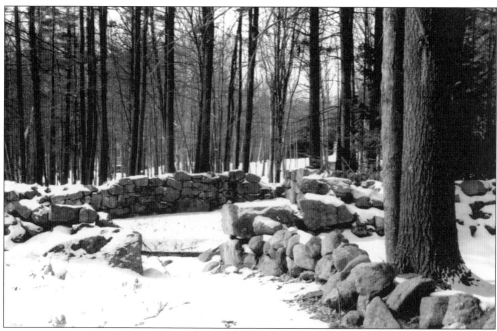

ANIMAL POUND. This fieldstone enclosure on Pembroke Hill Road and Fourth Range Road was built in 1813 in order to hold stray livestock until their owners could claim them. Most communities had similar structures, but few have survived. (Photograph by the author.)

CONTENTS

Acknowledgments

This book would not have been possible without the cooperation and generosity of many people, especially Charlie Mitchell of the Pembroke Historical Society, Pamela Stauffacher at the Pembroke Town Library, David Smolen at the New Hampshire Historical Society, Christy Smith at Pembroke Academy, Raymond Boivin at the State Forest Nursery, Ginger Kozlowski at the *Hooksett Banner*, Laura Bonk of the Allenstown Historical Society, Janet Anderson of the Pembroke Women's Club, Jane Swanson of the DAR, Brent Michiels, Regis Lemaire, Don Carrier, Dr. Vincent Greco, Bert Whittemore, and Marilyn Ross.

Special thanks are due to Jim Garvin and the Meet Me in Suncook Committee, who helped to identify many mystery photographs.

Lastly, and most importantly, I am most thankful for my wonderful family, particularly my husband and parents, for their unrelenting love and encouragement.

INTRODUCTION

Pembroke is located just southeast of Concord, New Hampshire's capital. It is bordered by Chichester and Epsom to the north, and Allenstown and Bow to the south. Pembroke is unique in that three of its borders are defined by rivers (the Soucook, Merrimack, and Suncook). In his 1855 book, *New Hampshire As It Is*, Edwin A. Charlton describes Pembroke's land rising from the rivers in "extensive and beautiful swells, which yield abundantly when properly cultivated." Typical of New England communities, Pembroke's main occupation was agriculture until the mid-1800s, when mass production of goods such as paper and printed cloth by mechanized mills became more profitable.

Visitors to the area may experience some confusion when trying to understand what is meant by "Suncook" versus "Pembroke," especially when inhabitants seemingly use these names interchangeably. This confusion can trace its origins back to the earliest European settlement of the area. In 1725 a group of "Indian fighters" from near Dunstable, Massachusetts, led by Capt. John Lovewell (or Lovell), drove the Native Americans out of New Hampshire and into Quebec in a series of bloody battles. Captain Lovewell was killed in one of these battles, but in 1728 those men who survived and the heirs of those who died in these fights were granted, by the Massachusetts colony, the area now known as Pembroke. This township was called Suncook, after the native name for the area. Controversy soon arose, however, when it was learned that a year earlier some of the same land had been granted by the colony of New Hampshire to the town of Bow. This was not as unusual an experience as one would think, since during that time there was a dispute over the boundary between Massachusetts and New Hampshire. While the colonies were fighting over the boundary, settlers started to make their homes and build meetinghouses in Suncook. Pembroke was incorporated on November 1, 1759. Gov. Benning Wentworth named the town after the Earl of Pembroke, one of his supporters. With Pembroke's incorporation, Suncook ceased to exist as far as New Hampshire was concerned. However, the inhabitants refused to give up the name entirely, and even now, the name Suncook is used to refer to the village that is partly contained within the town of Pembroke.

Pembroke is unique in that it has retained, for the most part, its Colonial system of range roads. In the 1730s, the proprietors drew lots for their parcels of land, which were to be at least 40 acres in size and of equal value to each other. The parallel roads that provided access to these lots were referred to as "range roads," and together with the cross-range roads that ran

perpendicular to them, a general grid was formed. Over time, some of these roads have disappeared, but many principal roads in town, such as Fourth Range Road, have kept their original designation to the present day.

In Pembroke's first census in 1767, the town's total population numbered 557 people. The earliest settlers lived, for the most part, along what are now Pembroke Street and the other range roads. The village area had been set aside for a sawmill and a gristmill, which needed water power from the river. In time, the village would add more streets to accommodate the increase in population. By 1855 the town had grown to 1,732 residents. Farming was the original principal activity in Pembroke. Until the mid-1900s, about 15 farms operated along Pembroke Street. The Buck Street area along the Suncook River, which divides the town from Allenstown, was a prime agricultural area that produced milk, strawberries, and cider.

The first mills in Suncook village were built by John Coffrin (or Cochran) around 1738. Samuel Daniell operated a fulling mill that processed wool in 1773. This area also had forges and paper mills in the early 1800s. Paper was a popular commodity, and about five paper mills existed in Suncook by 1820. The first cotton mill was built in 1811 by Maj. Caleb Stark. Production gradually shifted from paper to printed cotton textiles. Other industries in town included manufacturing of glass, nails, hammers, and bricks. Clay along the Merrimack River was ideal for making brick, which explains in part the prevalence of brick structures in town. A railroad connecting Pembroke to Concord and Portsmouth was completed in 1852, which benefited the growth of industry in the village but adversely affected the many taverns along Pembroke Street, the main road connecting Concord and Manchester.

The textile mills and other industries in town needed outside workers, since many of Pembroke's native inhabitants had their own farms to run and millwork was unattractive to them. Large numbers of workers were recruited from Quebec, and although this influx of French Canadians created some tensions, the immigration was a great boon to the local businesses and the cultural development of the town. The shops along Main Street thrived as all the new people in the village area demanded goods and services. At one point, French was the primary language spoken in the village. In 1885 the French Canadians formed a group called Le Cercle Dramatique et Litteraire, which provided lectures, concerts, plays, and a library.

Cotton manufacturing throughout New England began to decline as textile mills shifted to the southern region of the United States. Pembroke was not immune to this economic decline, even though production was shifted from textiles to furniture in the 1950s. Despite these setbacks, the village has seen some revitalization as Pembroke has become an attractive suburban community, due to its location between Concord and Manchester and its relative proximity to Interstate 93, a prime influence in the tremendous growth of southern New Hampshire in recent years.

I grew up in Pembroke after my family and I moved there in 1984. In researching this book, I have had the unique opportunity to gain a different perspective on my hometown. I now see familiar places that I used to take for granted with a much different awareness and appreciation. I sincerely hope that readers of this book will benefit from this new insight as well.

One
VIEWS

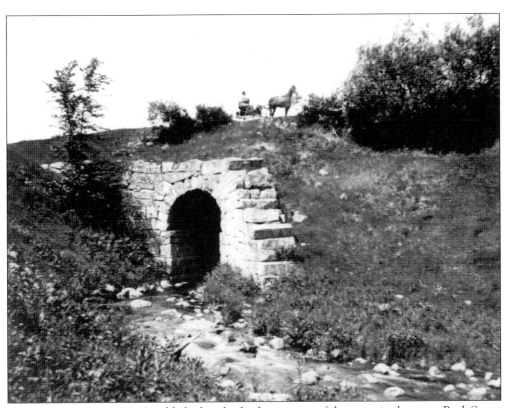

BRIDGE, EAST PEMBROKE. It is likely that this bridge was one of the many in the upper Buck Street area that crossed the Suncook River into Allenstown. (Courtesy of Pembroke Historical Society.)

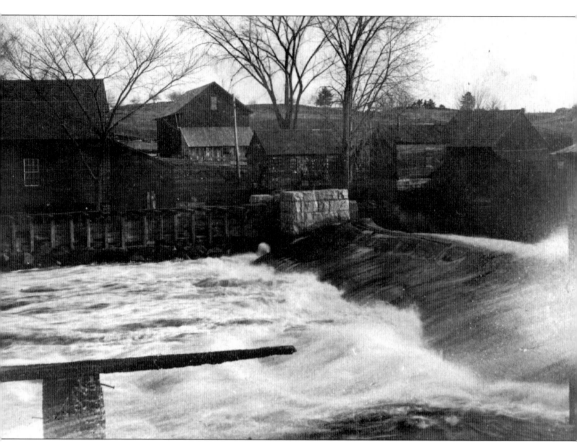

OSGOOD DAM, C. 1910. This view shows the Pembroke side of the Suncook River near the Turnpike Bridge. (Courtesy of Brent Michiels.)

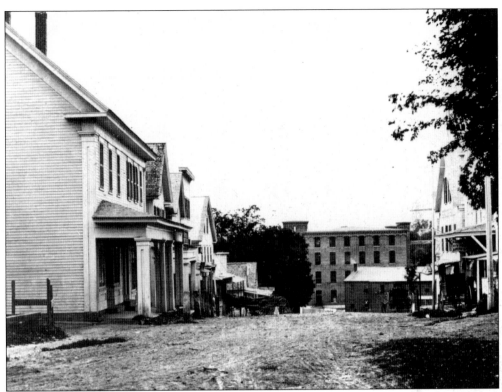

MAIN STREET. This is an early view of Main Street. Webster Mill is in the background. (Courtesy of Pembroke Historical Society.)

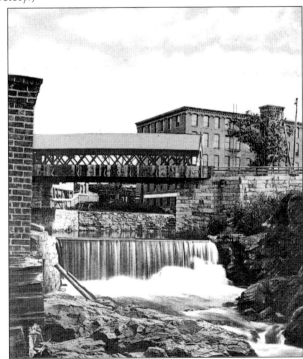

MAIN STREET BRIDGE AND PEMBROKE MILL DAM. This covered bridge was replaced in 1902 by the town of Pembroke and the Boston and Maine Railroad. The Pembroke Mill is in the background. (Courtesy of Brent Michiels.)

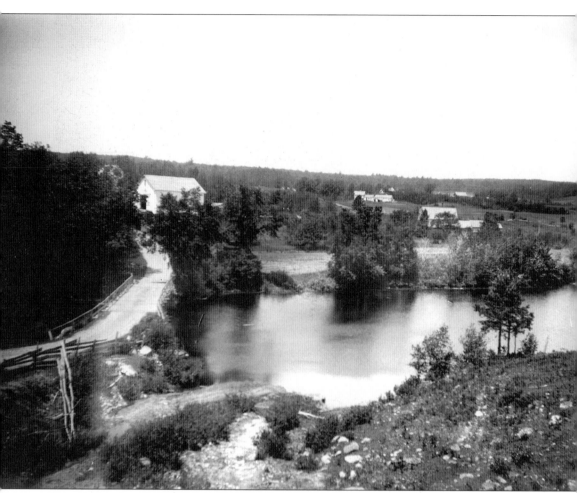

SOUCOOK SWIMMING HOLE. The Soucook River separates Pembroke from Concord. This view shows North Pembroke near the Chichester line, an area sometimes referred to as Horse Corner. (Courtesy of New Hampshire Historical Society.)

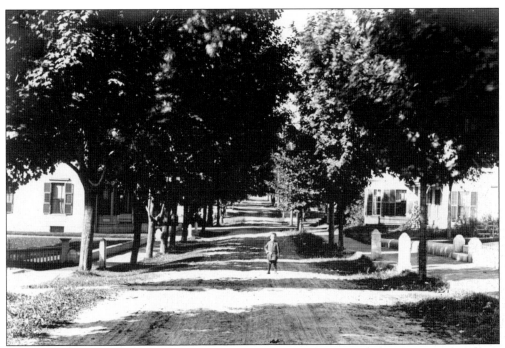

PROSPECT STREET, C. 1910. This street was laid out in 1876, parallel to and just west of Broadway, connecting Pine and Union Streets. (Courtesy of Pembroke Historical Society.)

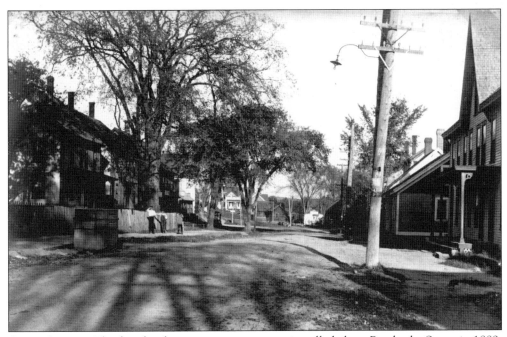

GLASS STREET. The first five lampposts in town were installed along Pembroke Street in 1889. Electricity was introduced in 1895. (Courtesy of Pembroke Historical Society.)

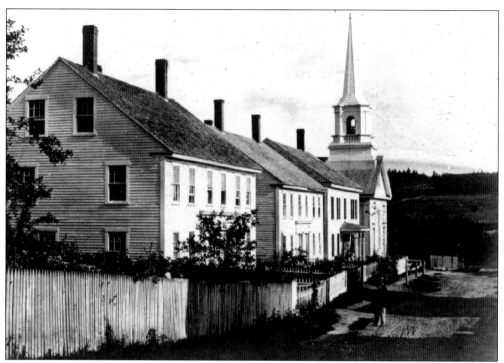

CHURCH STREET, C. 1870S. The three buildings on the left were built as housing for mill workers. The street gets its name from the Methodist church on the right, which was built in 1849. A parsonage was later built to the right of the church, on the present site of the Bank of New Hampshire. Both the church and parsonage were later destroyed by fire in October 1882. (Courtesy of Pembroke Historical Society.)

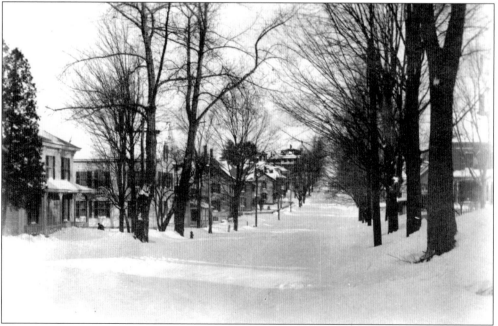

VIEW OF BROADWAY, FACING NORTH. Broadway was laid out in 1868. (Courtesy of Don Carrier.)

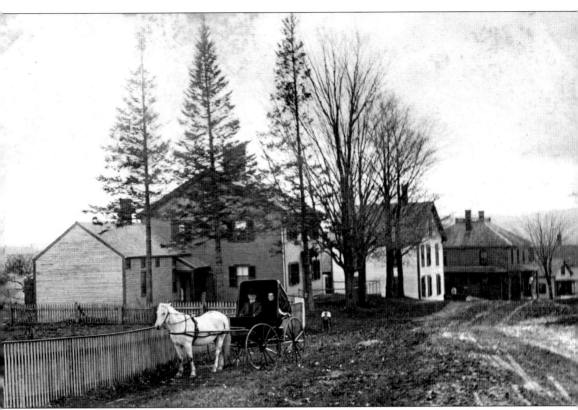

SUNSET HOUSE, C. 1892. Built on Main Street by William Kimball around 1815, Sunset House (on left) was a summer residence of Dr. Orlando B. Douglas (shown here with his wife, Maria). The white building to the right, called Hillholm, was also owned by Dr. Douglas and was used as a guesthouse. After 1906, the complex was used as a sanitarium, which was run by Dr. Charles Abbott. (Courtesy of Pembroke Historical Society.)

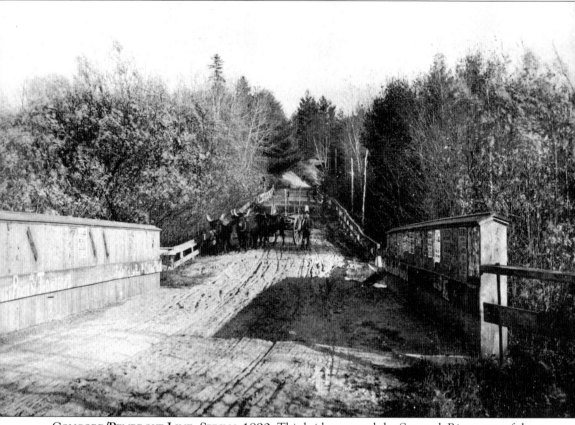

CONCORD/PEMBROKE LINE, SPRING 1890. This bridge crossed the Soucook River, one of three rivers that form Pembroke's boundaries. The first bridge on this site was built in 1841. A much wider bridge is located here today. (Courtesy of New Hampshire Historical Society.)

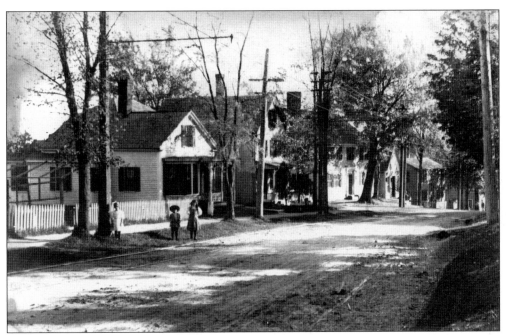

MAIN STREET, AFTER 1902. This scene is just above Church Street, downhill from Sunset House. (Courtesy of Pembroke Historical Society.)

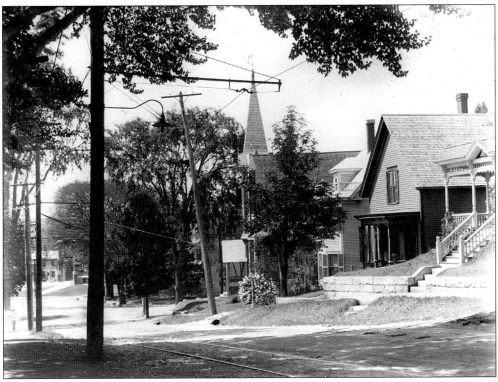

NORTH MAIN STREET. This photograph was taken on the present-day corner of Main and Church Streets, facing toward the Broadway intersection. (Courtesy of Brent Michiels.)

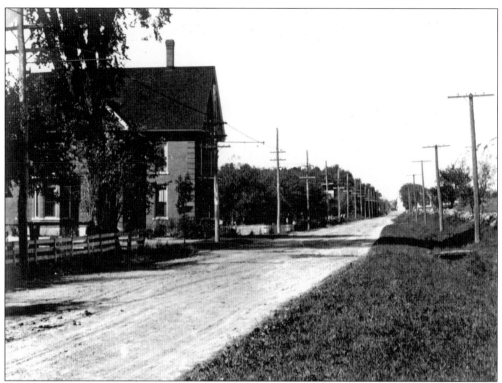

PEMBROKE STREET. Henry T. Simpson built this house, using bricks from his brickyard on the Merrimack River. (Courtesy of Pembroke Historical Society.)

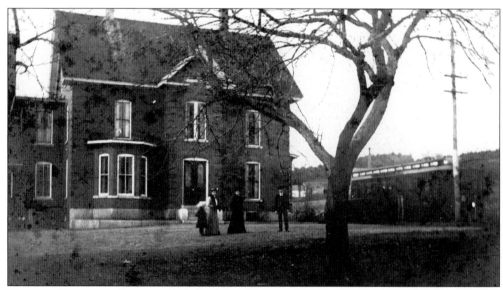

VIEW OF PEMBROKE STREET. A trolley route between Concord and Manchester ran through Pembroke from 1902 until 1927. (Courtesy of Pembroke Historical Society.)

CLOCK TOWER. The clock tower on the Williams and Hosmer Building in the village has long been a symbol for the town. Built in 1879 with wooden gears and a bell that weighs 500 pounds, the clock eventually fell into disrepair, but was restored in 1999, largely through the fund-raising efforts of the Meet Me in Suncook Committee. (Courtesy of Pembroke Historical Society.)

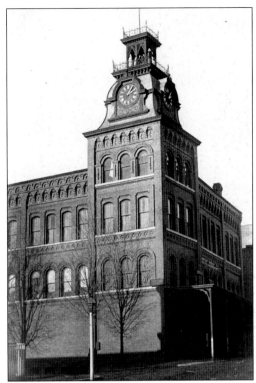

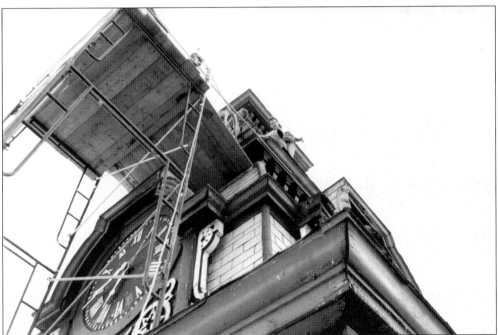

RESTORATION OF THE CLOCK AND TOWER, AUGUST 1999. Mark Julien and Tony Williams make repairs to the copper sheathing on the clock tower. The restoration of the clockworks by Phil D'Avanza would win an award from the New Hampshire Preservation Alliance in 2001. (Photograph by Eric Baxter; courtesy of *Hooksett Banner*.)

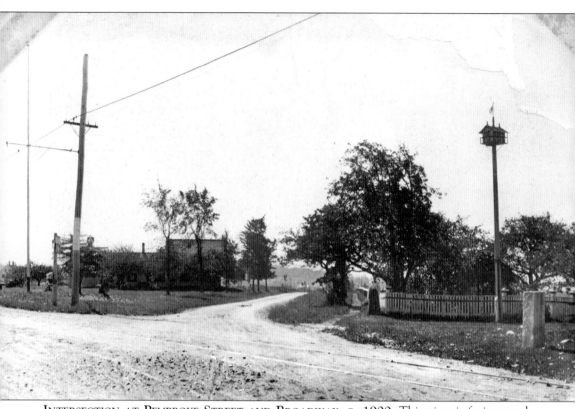

INTERSECTION AT PEMBROKE STREET AND BROADWAY, C. 1900. This view is facing south. The field to the left is now Pembroke Park. (Courtesy of Pembroke Historical Society.)

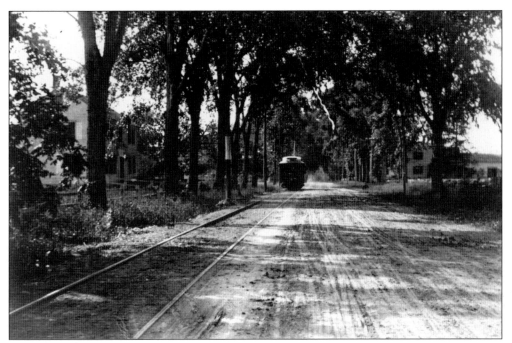

PEMBROKE STREET TROLLEY. A trolley ran along Pembroke Street and down Whittemore Road, across the Merrimack River to Concord. The trolleys ran from about 1902 until buses took over in 1927. (Courtesy of Pembroke Historical Society.)

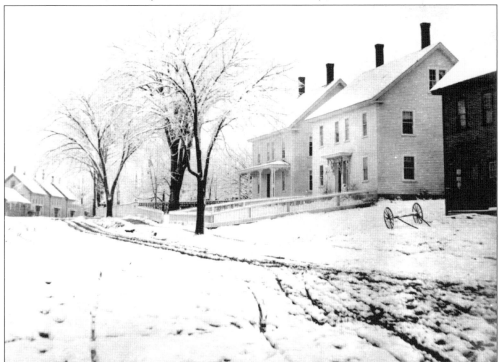

GLASS STREET AND TURNPIKE STREET, 1867. Glass Street is named for the glass factory that operated in the village in the 1840s. (Courtesy of Brent Michiels.)

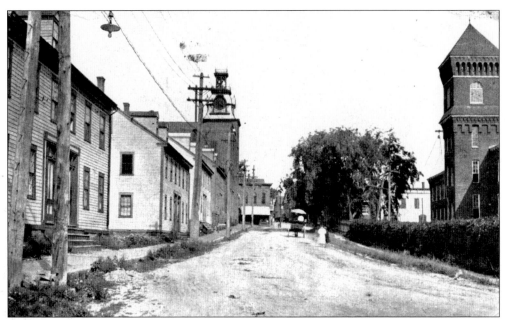

FRONT STREET, C. 1910. The Pembroke Mill, built in 1900, is seen on the right. On the left side of the street are mill workers' homes. (Courtesy of Pembroke Historical Society.)

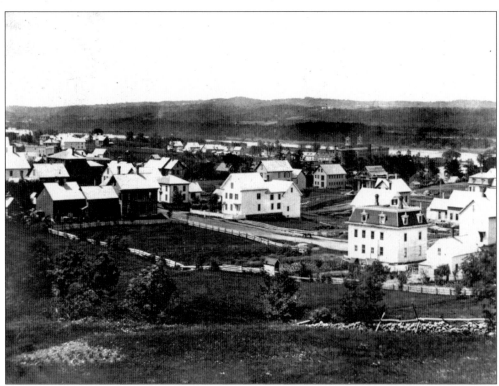

VIEW OF TOWN. Incorporated in 1759, Pembroke was named after the Earl of Pembroke, a political supporter of New Hampshire's governor, Benning Wentworth. (Courtesy of Pembroke Historical Society.)

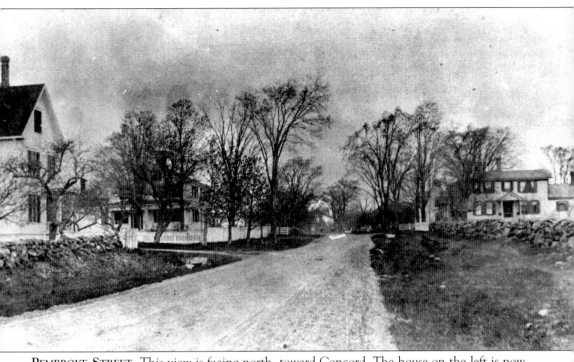

PEMBROKE STREET. This view is facing north, toward Concord. The house on the left is now Greco Chiropractic Offices. (Courtesy of Dr. Vincent Greco.)

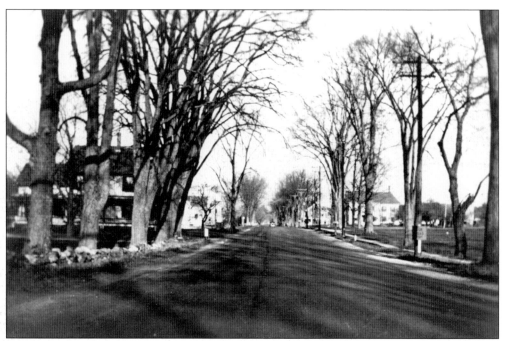

PEMBROKE STREET, EARLY 1930S. Unfortunately, as happened in many New England communities, Dutch elm disease killed many trees that lined the streets. (Courtesy of New Hampshire Historical Society.)

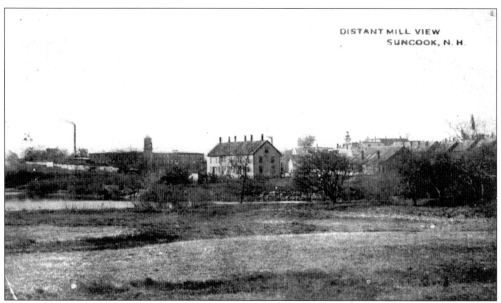

DISTANT MILL VIEW. The first mills in Suncook were built around 1738 by John Coffrin (or Cochran). The first mills sawed lumber, processed wool, or made paper, but production had shifted to cotton textiles by the mid-1800s. (Courtesy of Pembroke Historical Society.)

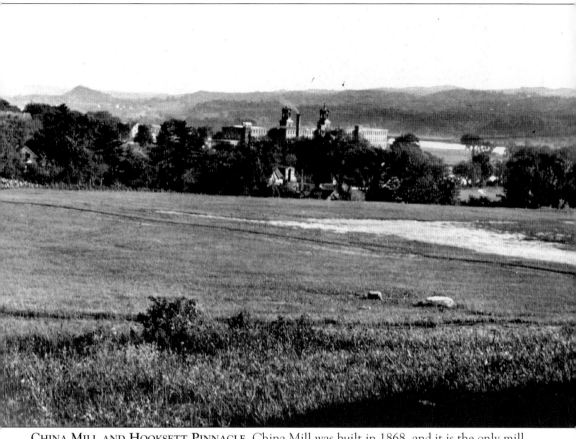

CHINA MILL AND HOOKSETT PINNACLE. China Mill was built in 1868, and it is the only mill in Pembroke that is still in operation. (Courtesy of Pembroke Historical Society.)

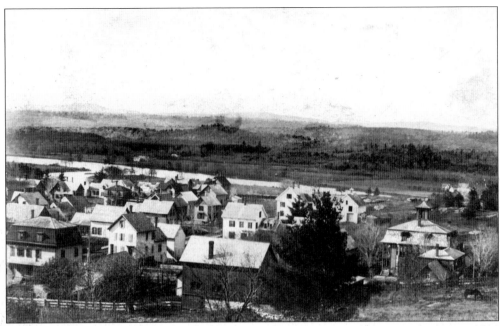

DISTANT VIEW OF PEMBROKE. Pembroke is located on land granted by Massachusetts in 1728 as "Suncook" to the survivors and heirs of the "Indian fighter" group that had been led by Capt. John Lovewell. (Courtesy of Pembroke Historical Society.)

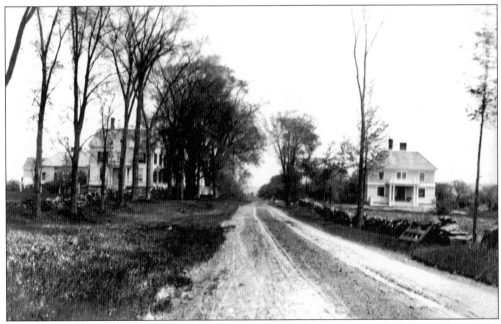

DEARBORN ROAD. Shown on the left is the J. H. Dearborn House, built around 1800 by Solomon Whitehouse. The house to the right still exists today. (Courtesy of Pembroke Historical Society.)

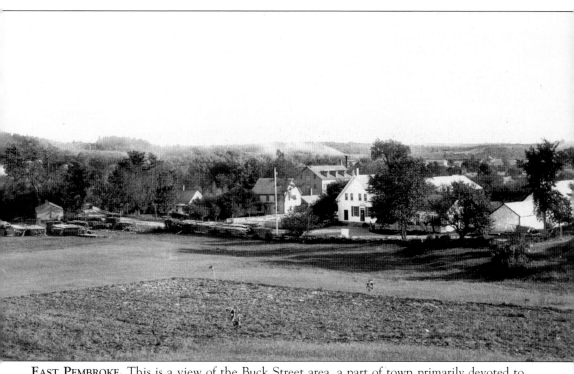

EAST PEMBROKE. This is a view of the Buck Street area, a part of town primarily devoted to agriculture. (Courtesy of Brent Michiels.)

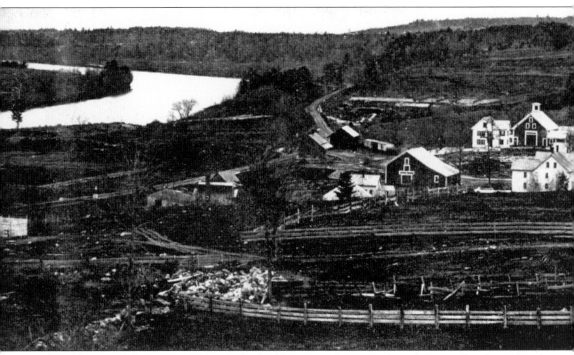

VIEW OF THE MERRIMACK RIVER. The buildings seen here are, from left to right, the railroad station, C. H. Ruggles's livery stable, and the Hall Wilkins residence. (Courtesy of Pembroke Town Library.)

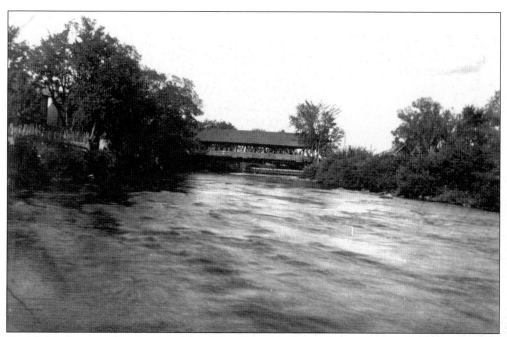

TURNPIKE BRIDGE. This bridge crossed the Suncook River where a double-decker bridge now stands. The first bridge on this site was built by Asa Robinson for the Chester Turnpike Company in 1805 for $1,000. (Top photograph courtesy of Pembroke Historical Society; bottom photograph courtesy of Brent Michiels.)

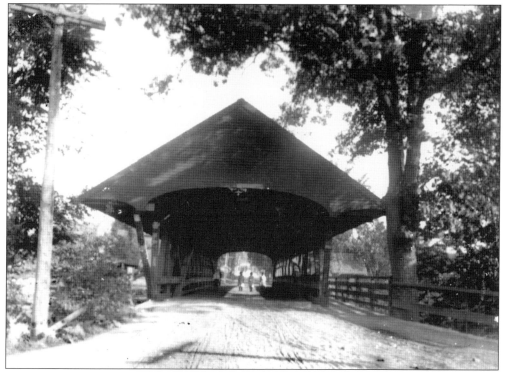

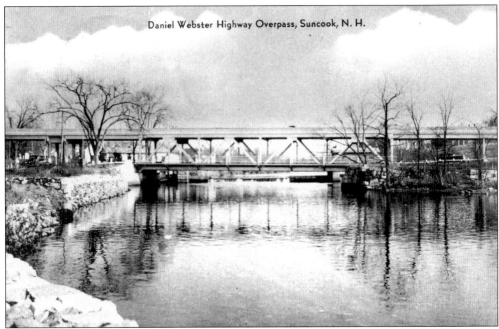

Daniel Webster Highway Overpass, Suncook, N. H.

DANIEL WEBSTER HIGHWAY OVERPASS, AFTER 1939. This bridge replaced the covered Turnpike Bridge (sometimes referred to as Osgood Bridge) in 1929. (Courtesy of Don Carrier.)

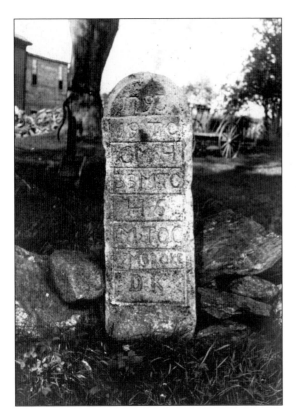

MILESTONE. This 1793 granite tablet on Pembroke Street, just north of Dearborn Road, reads "1793, 19 to CMH, 35 M to H, 6 M to C, Pembroke, DK." "CMH" refers to the Chester Meetinghouse (Pembroke Street was originally part of the Chester Turnpike), "H" stands for Haverhill, Massachusetts, and "C" stands for Concord. The numbers indicate distances in miles. "DK" refers to David Kimball, the owner of the tavern near the milestone. (Courtesy of Pembroke Historical Society.)

WINTER OF 1920. Snowy winters are not uncommon in New Hampshire and Pembroke suffered a particularly severe one in 1920. These views show the snow piled high along the trolley tracks. (Courtesy of Dr. Vincent Greco.)

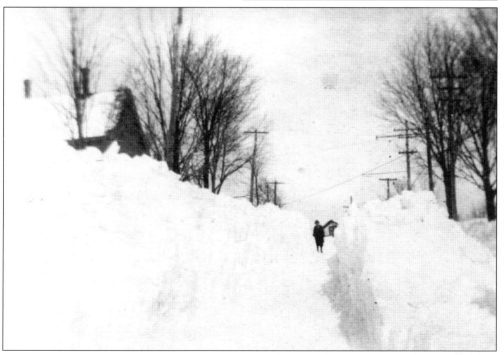

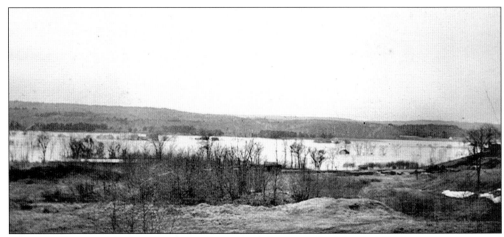

VIEW OF BOW FROM THE SUNCOOK GRAMMAR SCHOOL. In March 1936 heavy rains caused many rivers in the region to overflow their banks. This is a westward view from Suncook village, toward Bow, across the Merrimack River. (Courtesy of Pembroke Historical Society.)

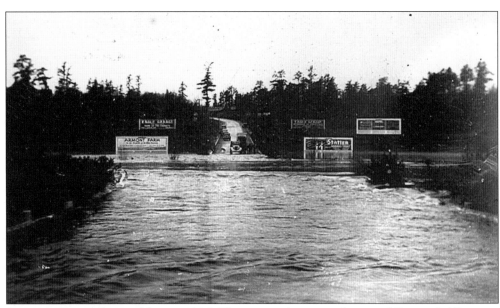

SOUCOOK RIVER FLOOD, MARCH 1936. This view is facing north, toward Concord. (Courtesy of Pembroke Historical Society.)

Two
PEOPLE

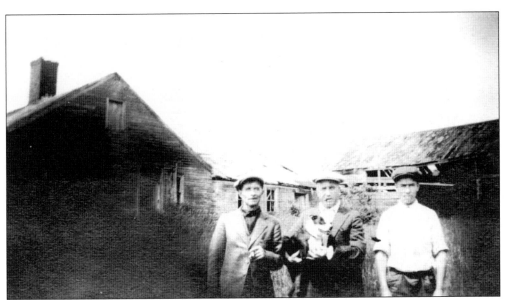

TRUEWORTHY FOWLER, WILLIAM DROUGHT, AND WILLIAM SAWYER. This image was taken in North Pembroke in 1932. Trueworthy Fowler was very active in town, serving in a variety of posts, and he helped research the town history that was published in 1895. (Courtesy of Brent Michiels.)

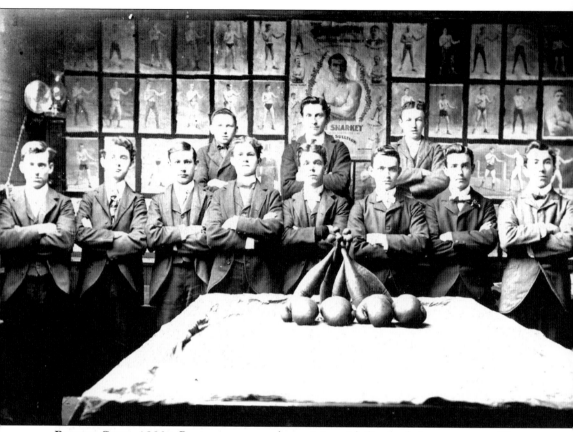

BOXING CLUB, 1880s. Boxing was a popular activity with Pembroke's young men. (Courtesy of Regis Lemaire.)

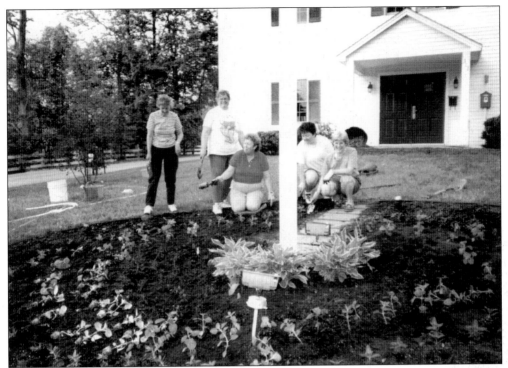

PEMBROKE WOMEN'S CLUB. The Pembroke Women's Club is involved in many community projects, including gardening (shown here in front of the town hall), and raising money for scholarships and other causes and activities. (Courtesy of Jane Swanson.)

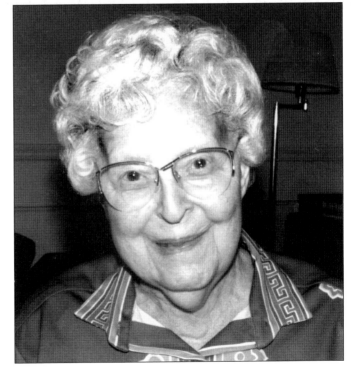

HELEN FOSS. Helen Foss helped found the Pembroke Women's Club in 1924. This photograph was taken in 1999, when Helen was 96 years old. (Photograph by Ginger Kozlowski; courtesy of *Hooksett Banner*.)

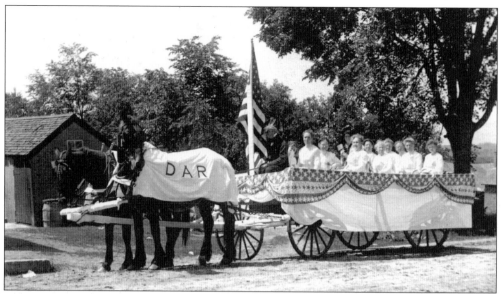

DAUGHTERS OF THE AMERICAN REVOLUTION FLOAT, JULY 4, 1914. Organized with 14 members in 1896, the Buntin chapter of the Daughters of the American Revolution (DAR) is named for Andrew Buntin, one of the first settlers of what is now Allenstown. Buntin commanded a company from New Hampshire in the Revolutionary War and died at the Battle of White Plains in 1776. (Courtesy of Dr. Vincent Greco.)

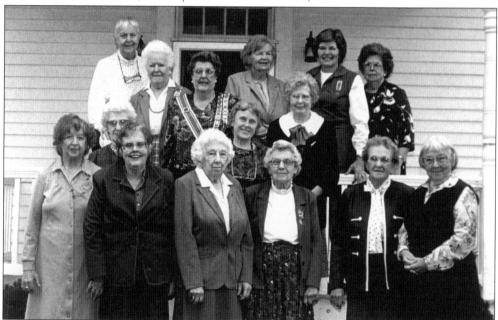

DAUGHTERS OF THE AMERICAN REVOLUTION, BUNTIN CHAPTER, 1990. The Buntin chapter of the DAR merged with the Rumford and Abigail Webster chapters in June 2001. DAR members pictured are, from left to right, as follows: (first row) Bernice Morgan, Anne French, Evelyn Grint, Alice Foss, Mathel Lougee, and Dot Sundgren; (second row) Lucy Pratt, Evelyn Lavoie, Evelyn Woodbury; (third row) Lucy Cutting, Marion Kittridge, Sara Smith, Rita Morgan, Janet Anderson, and Janet Woodbury. (Courtesy of Janet Anderson.)

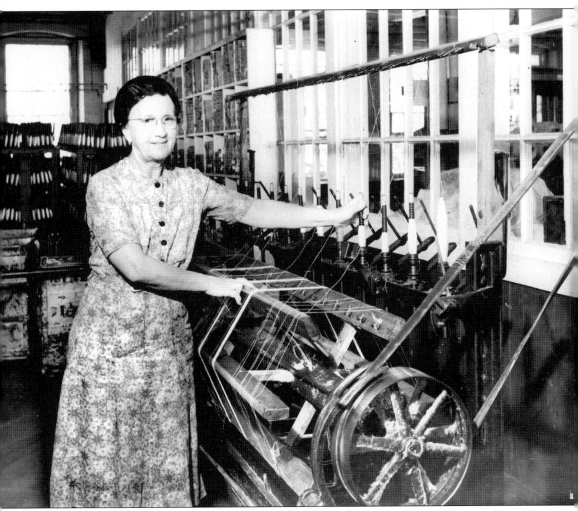

LAURA LEMAIRE, C. 1945. This photograph was taken at a celebration commemorating Laura Lemaire's 50 years of employment at the China Mill. (Courtesy of Regis Lemaire.)

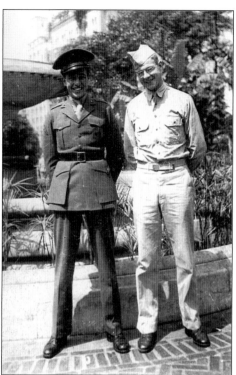

EDDIE AND IRVING ATWOOD, 1944.
Pembroke residents have served in every
war from the French and Indian War to
the present. Of all those who served in World
War II, five from Pembroke lost their lives.
(Courtesy of Bert Whittemore.)

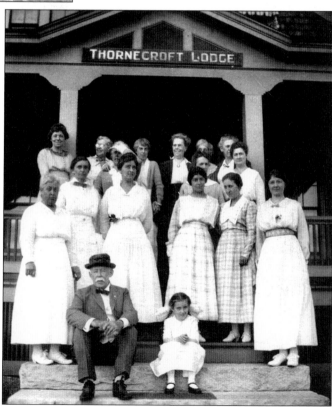

THORNECROFT LODGE.
Pictured here are members
of the Young Women's
Missionary Society (and
guests) at one of the group's
meetings in 1919. (Courtesy
of New Hampshire
Historical Society.)

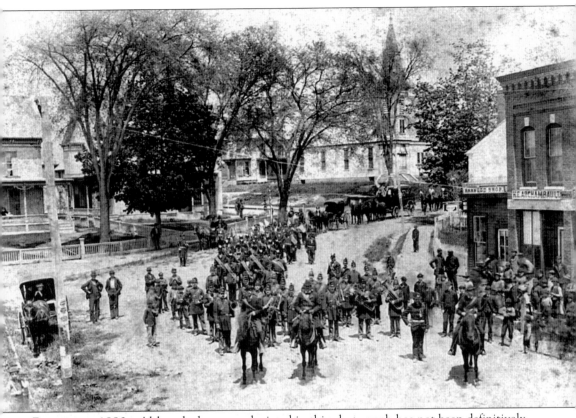

PARADE, C. 1890s. Although the event depicted in this photograph has not been definitively identified, the location is Main Street, sometime after 1879, when the church in the background was built. The appearance of what seems to be a hearse at the end of line suggests this may be a funeral procession, possibly that of Pembroke resident George Lamiette, who perished in the battleship USS *Maine* explosion of 1898. (Courtesy of Brent Michiels.)

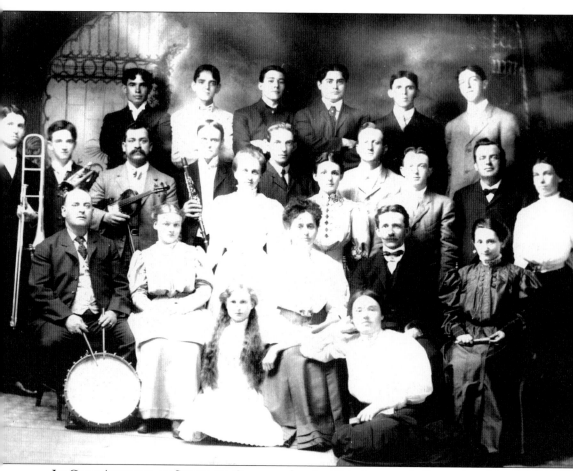

Le Club Amateur de Suncook. Groups such as Le Club Amateur de Suncook and Le Cercle Dramatique et Litteraire (the latter founded in January 1885) produced plays, dramatic readings, and concerts. Most of the productions were in French, since that was the prevalent language in the village at the time. (Courtesy of Regis Lemaire.)

LES FIANCÉES D'ALBANO, **1923.** This production by Le Club Amateur de Suncook was directed by Philip Levesque. (Courtesy of Regis Lemaire.)

LES BELLARON. This was another production by Le Club Amateur de Suncook. Director Philip Levesque is seated in the wicker chair at the center of the first row. (Courtesy of Regis Lemaire.)

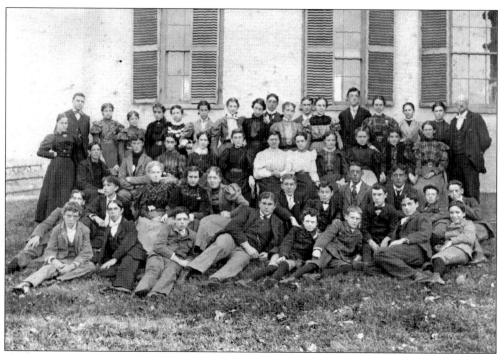

PEMBROKE ACADEMY STUDENTS AND STAFF. This group portrait was taken during the 1890s. (Courtesy of Pembroke Town Library.)

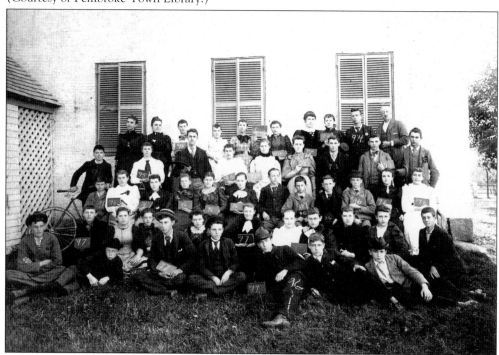

PEMBROKE ACADEMY STUDENTS AND STAFF. The academy students in this image were in the classes of 1894 through 1897. (Photograph by H. C. Bailey; courtesy of Pembroke Historical Society.)

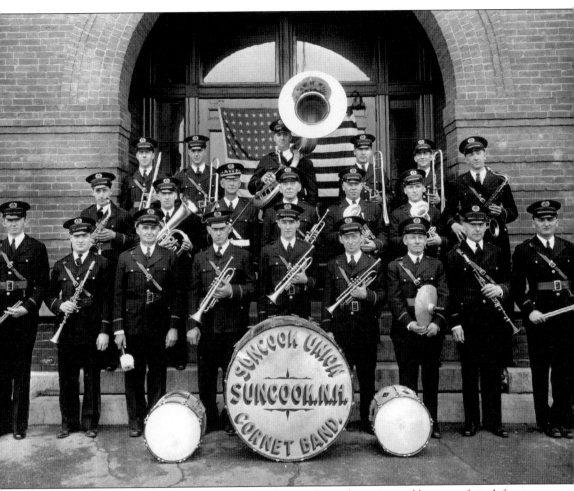

SUNCOOK UNION CORNET BAND, BEFORE 1959. Band members pictured here are, from left to right, as follows: (first row) Arthur Lemaire, Wilfred Bonefant, George Bellerose, Oscar Girard, Albert ?, Albert Bonefant, Ovila Havail, Maynard Georgi, and Romeo Bellerose; (second row) Arthur Girard, Joseph Bonefant, John Bellerose, George Georgi, unidentified, and Leo Courtemanche; (third row) Raymond Laronde, Octane Bellerose, Albert Bellerose, Albert Blais, unidentified, and L. Dupont. (Courtesy of Regis Lemaire.)

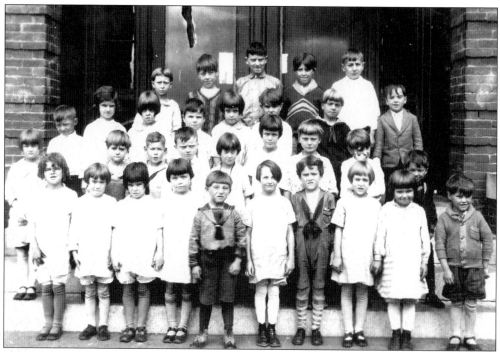

STUDENTS FROM HIGH STREET SCHOOL. This photograph was taken about 1928. (Courtesy of Pembroke Historical Society.)

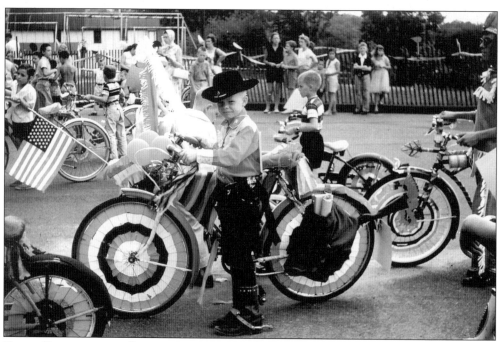

TOWN BICENTENNIAL CELEBRATION, 1959. Shown here is Jim Ross with his entry in the bicycle decorating contest. (Courtesy of Marilyn Ross.)

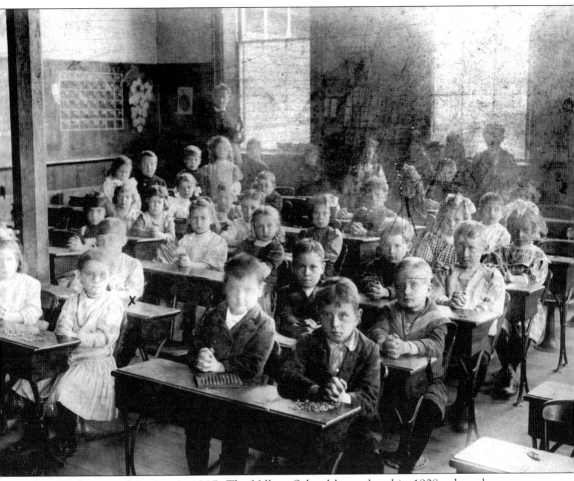

VILLAGE SCHOOL STUDENTS, 1905. The Village School later closed in 1908, when the new High Street School opened. (Courtesy of Pembroke Historical Society.)

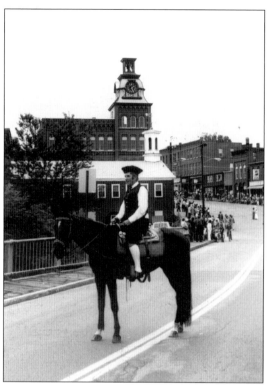

BICENTENNIAL PARADE, JULY 31, 1976.
Shown here is marshal Edgar Bellerose
at the head of the parade celebrating
the nation's bicentennial. (Courtesy of
Brent Michiels.)

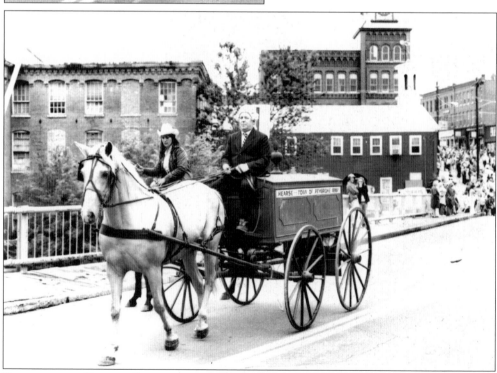

BICENTENNIAL PARADE, JULY 31, 1976. Oscar Plourde is driving the town hearse, which dates
to 1861. (Courtesy of Brent Michiels.)

WAR MEMORIAL, 1912. Located in Pembroke Park, at the intersection of Pembroke Street and Broadway, this monument was dedicated in September 1912 to commemorate the town residents who lost their lives in the Civil War. Over the years, other memorials for those who served in the Spanish-American War, both World Wars, Korea, Vietnam, and the Persian Gulf War have been erected either in Pembroke Park or in George Lamiette Square, at the south end of Broadway. (Courtesy of Don Currier.)

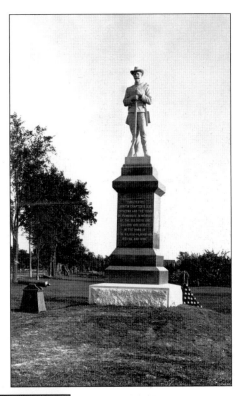

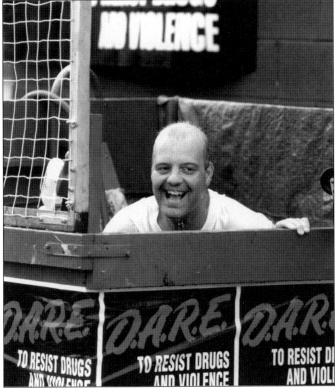

OLD HOME DAY, 1997. Parades, concerts, fireworks, and games have been a part of Pembroke's Old Home Day since 1899. The celebration of town spirit was held sporadically throughout the early 1900s, but for the last several decades it has been held annually on the last Saturday in August. Here Pembroke Academy headmaster John Graziano gets a soaking in the dunking booth. (Courtesy of *Hooksett Banner*.)

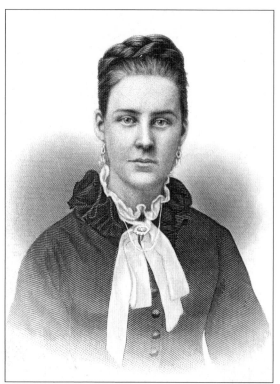

JOSIE LANGMAID. One of the saddest and most gruesome moments in Pembroke's history occurred on the morning of October 4, 1875. Josie Langmaid, age 17, was murdered while walking from her home on Buck Street to Pembroke Academy. When she failed to arrive at school, a search party was formed. Later that evening, her decapitated body was found in the woods less than a quarter mile from the academy. The next day her severed head was found 1,100 feet from her body. Joseph LaPage, a French woodchopper, was convicted of the murder after two trials, and was executed in Concord in March 1878. The incident sparked some anti-French sentiment in town. (Engraving from *The Murdered Maiden Student: A Tribute to the Memory of Miss Josie A. Langmaid,* by Rev. S. C. Keeler; courtesy of Pembroke Academy Library.)

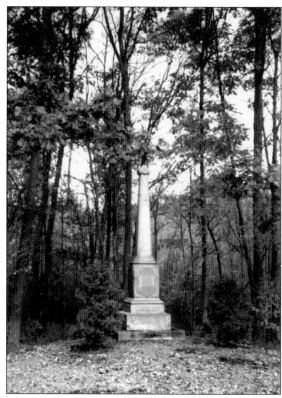

JOSIE LANGMAID MONUMENT. This memorial was erected in 1875 on Academy Road, near the site of Josie's murder. (Photograph by the author.)

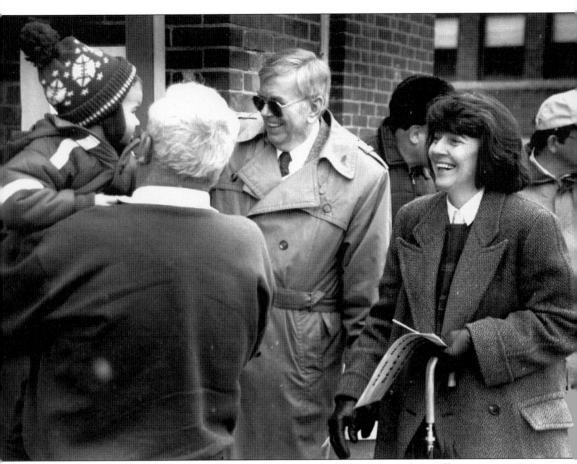

GERRY AND JOYCE BELANGER AT POLLS, MARCH 1997. March is traditionally town meeting season in New Hampshire. Townspeople gather together and vote on important town and school district matters, including expenditures. March is also the time for town elections for offices such as selectmen, school board members, and library trustees. (Photograph by Bruce A. Taylor; courtesy of *Hooksett Banner*.)

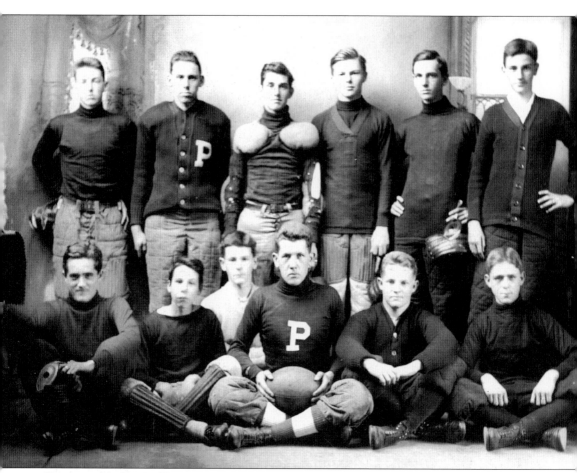

PEMBROKE ACADEMY FOOTBALL TEAM, 1913. It is unclear when football was discontinued at Pembroke Academy, although it was probably during the 1920s. The sport returned as a varsity program in 2000. (Courtesy of Pembroke Town Library.)

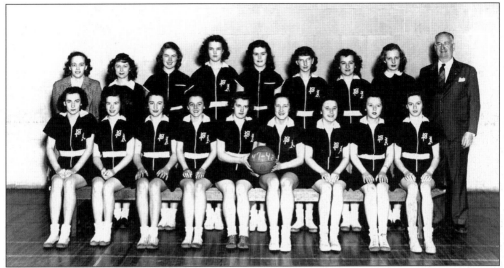

PEMBROKE ACADEMY GIRLS' BASKETBALL TEAM, 1947–1948. Pictured from left to right are the following: (first row) M. Hillman, N. Morse, A. Bussiere, F. Hyland, ? Yeaton (captain), J. Wright, P. Drought, R. Pfefferle, and S. Beal; (second row) ? Batchelder (assistant coach), J. Plourde (manager), P. Morse, N. Wells, J. Hillman, P. Brown, N. Mitchell, P. Johnson (manager), and ? Beal (coach). The team's record for the season was a disappointing 3-12. The all-star game that year was played at Pembroke on March 9, where Rita Pfefferle received the championship medal for foul shooting. Center Janice Wright was the high scorer for the season with 161 points. (Courtesy of the Pembroke Town Library.)

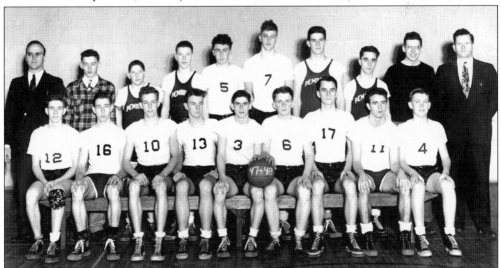

PEMBROKE ACADEMY BOYS' BASKETBALL TEAM, 1947–1948. The Pembroke boys were 7-11 for the 1947–1948 season. Edwin Child was the season's high scorer with 147 points, and he won both the foul shooting contest and the good sportsmanship trophy at the all-star game played at Pembroke Academy on March 9. Pictured from left to right are the following: (first row) E. Mozier, R. Bergevin, J. Sanderson, R. Blackmar, ? Crafts (co-captain), ? Child (co-captain), F. Whittemore, H. Gagne, and C. Gile; (second row) ? Lewis (coach), C. Yeaton (assistant manager), W. Crafts, R. Young, N. Connor, D. Ober, H. Warren, R. Courtemanche, M. Johnson (manager), and ? Currier (coach). (Courtesy of Pembroke Town Library.)

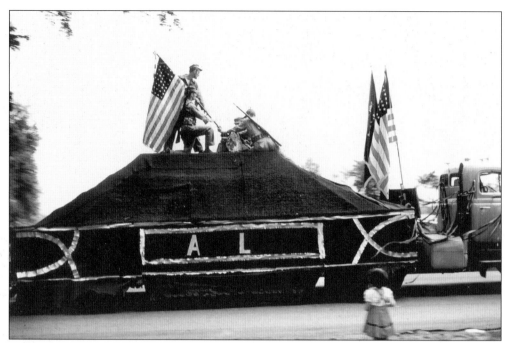

TOWN BICENTENNIAL PARADE, 1959. Shown here are the American Legion's float (above) and the Grange's entry (below). (Courtesy of Marilyn Ross.)

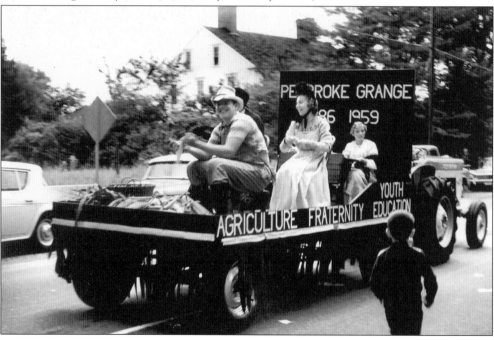

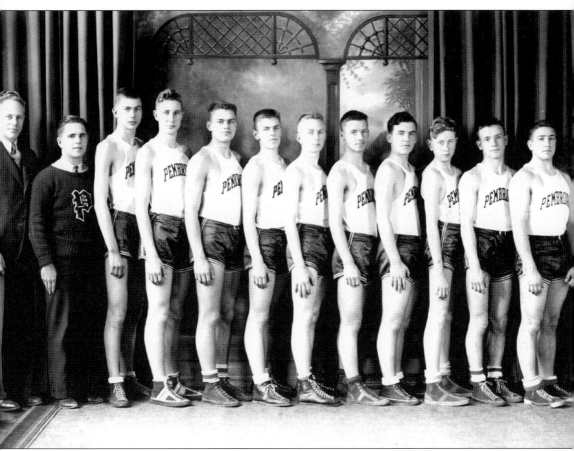

PEMBROKE ACADEMY BOYS' BASKETBALL, 1937. Pictured from left to right are John Peterson (coach), Hermas Daviault, Ralph McKay, George Hummer, Gordon MacKenzie, Eddie Eaton, Donald Woodard, Ralph Follansbee, Chester Richard, Richard Moran, Hector Campbell, and Percy Monty. (Courtesy of Pembroke Town Library.)

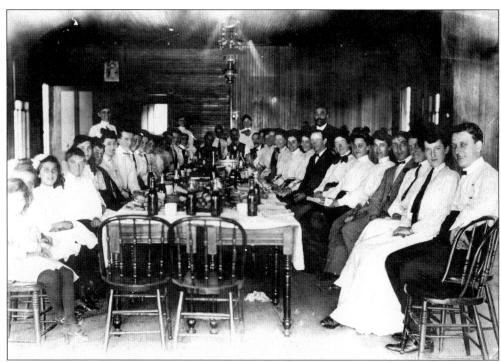

SUNCOOK HALL INTERIORS. Suncook Hall, a large function venue on Main Street, provided a place for large celebrations such as those pictured here. (Courtesy of Regis Lemaire.)

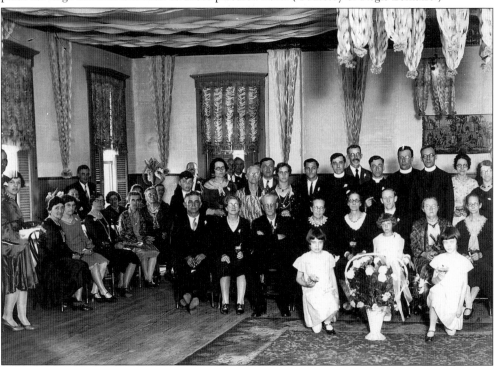

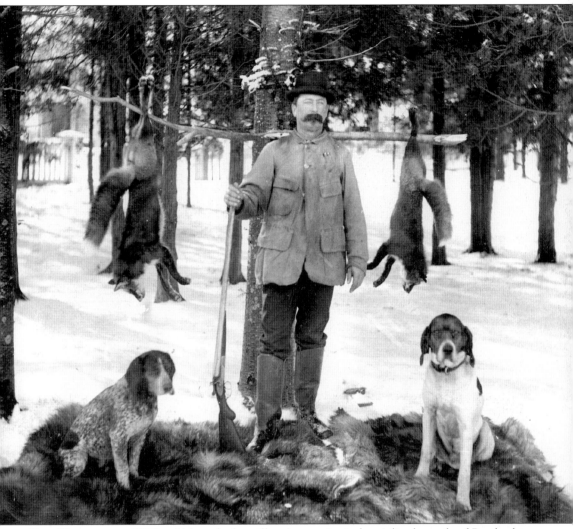

FOX HUNTER, C. 1920S. Although the village was quite industrialized, much of Pembroke itself was still agrarian. Foxes were a menace to poultry and other livestock. (Courtesy of Regis Lemaire.)

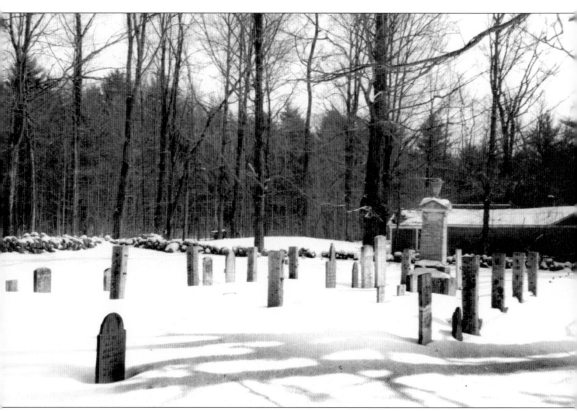

OLD NORTH PEMBROKE CEMETERY. Within this cemetery is the grave of Hermon Fife (1800–1845), whose epitaph claims he invented the revolver. Fife, an avid hunter, in 1835 designed and built a pistol with a cylinder that was revolved by hand. However, a much more advanced revolver design was patented by Samuel Colt in 1836. (Photograph by the author.)

Three

HOMES

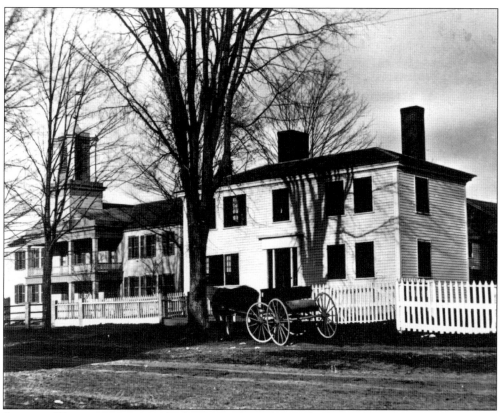

GILBERT HOUSE, C. 1880s. The house on the right was built by Joshua Gilbert about 1826. Mrs. Mary Emery lived there in the 1890s. The building to the left is Pembroke Academy. (Courtesy of Pembroke Historical Society.)

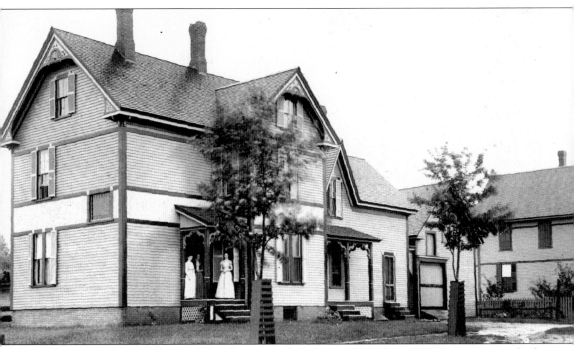

HOUSE ON MAPLE STREET. This house on the corner of Maple and High Streets was built sometime after 1895. Maple Street was laid out in 1876, along with Prospect and Pine Streets. (Courtesy of Pembroke Historical Society.)

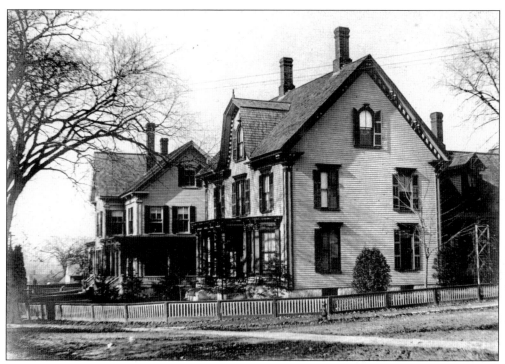

EMERY HOUSES. Located to the right of the Methodist church on Main Street, these homes were built by Joseph Morrill Emery (on left) and Natt B. Emery (on right). (Courtesy of Pembroke Historical Society.)

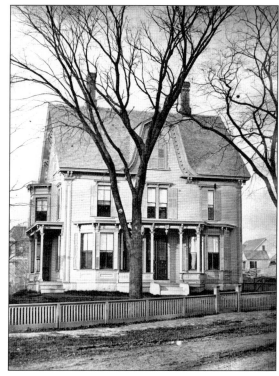

NATT B. EMERY HOUSE. This house is located on the corner of Main Street and Broadway. (Courtesy of Pembroke Historical Society.)

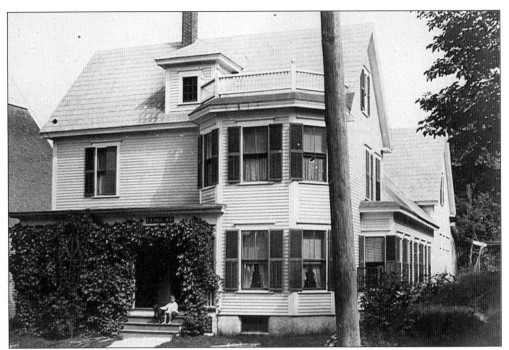

HILL HOUSE, C. 1910. This residence is on Main Street, across from Church Street, on the site of a house that burned in the 1870s. At the time this photograph was taken, this home was occupied by E. E. Hill, M.D., who also served as secretary to the Pembroke Academy Board of Trustees in 1910. (Courtesy of Pembroke Historical Society.)

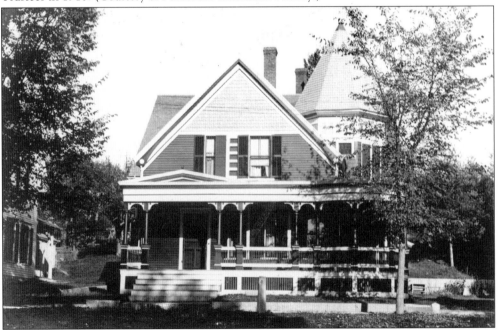

GEORGE GEORGI HOME. George Georgi moved to Pembroke in 1889 and founded Georgi's Bakery. He also directed the Suncook Union Cornet Band for many years before his death in 1956. This house is on Broadway, across from Pleasant Street. (Courtesy of Pembroke Historical Society.)

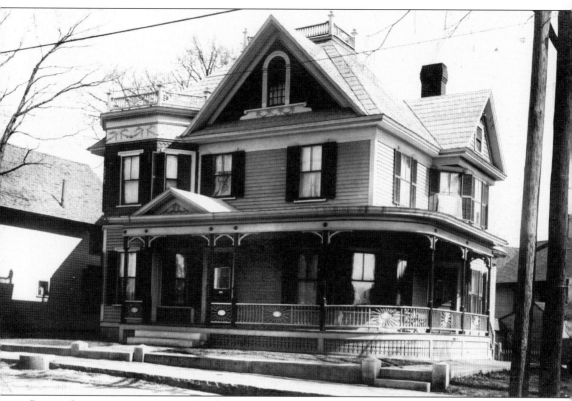

JACOB CHICKERING HOUSE. This house, located on Main Street at the foot of Broadway, is currently Petit's Funeral Home. It was built around 1900 by Jabez Chickering's brother, Jacob, who had a jewelry store on the east side of Main Street. (Courtesy of Pembroke Historical Society.)

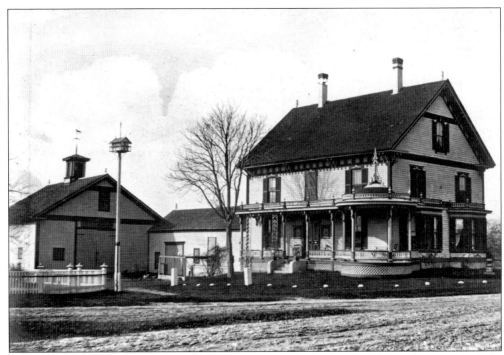

WILSON HOUSE. This house at the intersection of Pembroke Street and Broadway was built by Moody K. Wilson. (Courtesy of Pembroke Historical Society.)

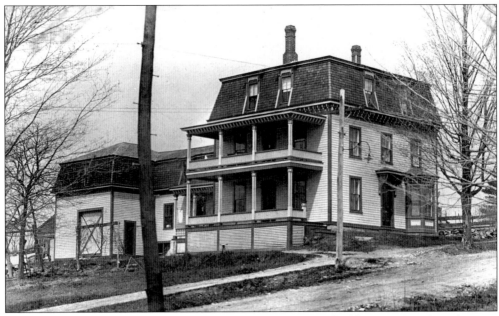

JOHN H. MORGAN HOUSE. The exterior of this apartment building on Broadway has not changed much in 100 years. (Courtesy of Pembroke Historical Society.)

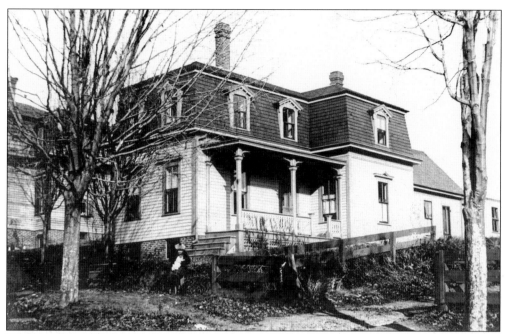

THOMAS EMERY HOUSE. Built by Thomas Emery, this home stands on the east side of Broadway. It was owned by Henry H. Hartwell in 1895. (Courtesy of Pembroke Historical Society.)

SNOW HOUSE. This residence at the corner of Broadway and Maple Street was originally owned by Mrs. Grace V. Snow. (Courtesy of Pembroke Town Library.)

HUTCHINSON HOUSE. This home is on Pembroke Street, across from Whittemore Road. This area of town was sometimes referred to as Hobbs Corner, named after the Isaac Hobbs House located next door to this one. Lyman C. Hutchinson constructed this house on land that belonged to the Hutchinson family as far back as 1797. (Courtesy of Pembroke Historical Society.)

KIMBALL TAVERN, C. 1895. This tavern on Pembroke Street, just north of Dearborn Road, was built in 1780 by Capt. David Kimball and is the first house in town constructed with double walls. (Courtesy of Pembroke Historical Society.)

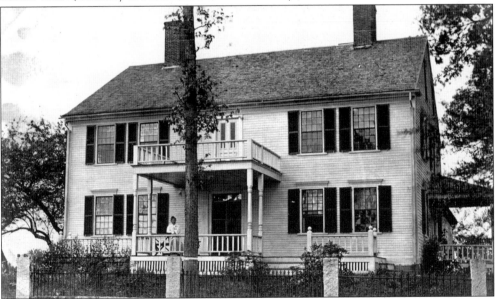

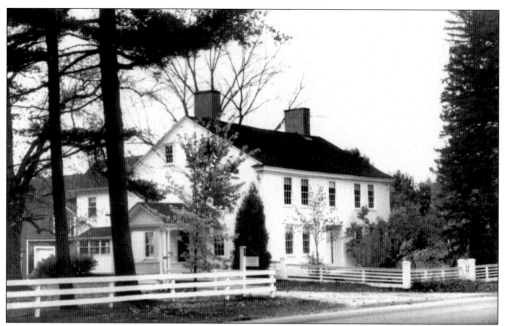

WHITTEMORE HOMESTEAD. This residence is located just north of the town's oldest cemetery, which dates from around 1740 and is the resting place of Aaron Whittemore, the town's first minister. The home is also near the site of the town's first meetinghouse. (Photograph by the author.)

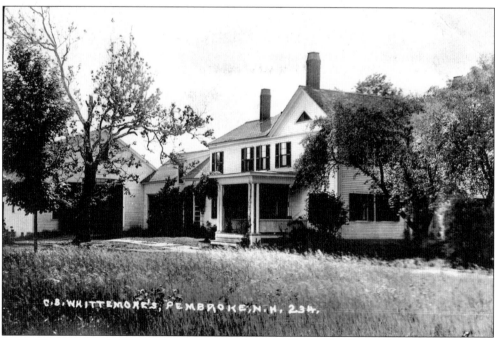

C. B. WHITTEMORE'S HOME. Located across from the Pembroke Street Cemetery, this house was built by Aaron Whittemore Jr. (Courtesy of New Hampshire Historical Society.)

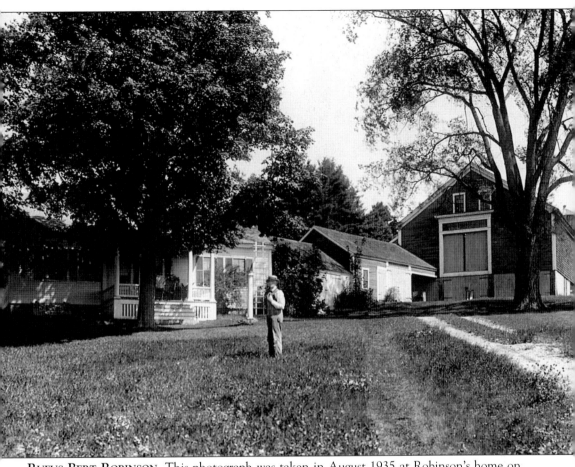

Rufus Bert Robinson. This photograph was taken in August 1935 at Robinson's home on Pembroke Street. (Courtesy of Bert Whittemore.)

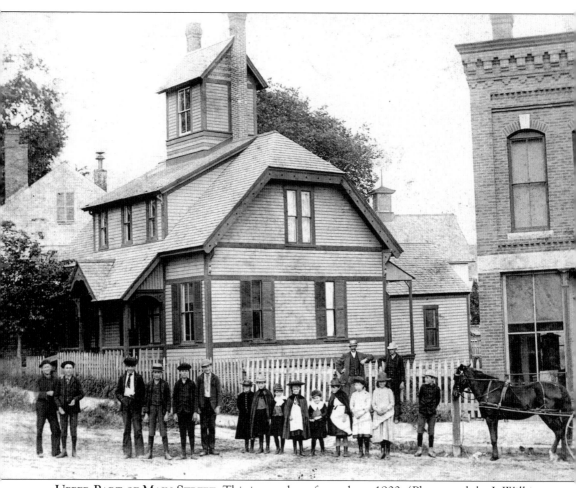

UPPER PART OF MAIN STREET. This image dates from about 1900. (Photograph by J. Wilkins; courtesy of New Hampshire Historical Society.)

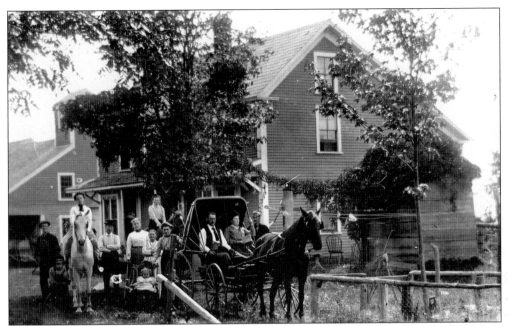

WILLIAM LAKE ROBINSON HOUSE AND FAMILY. The Robinson residence was located in North Pembroke, not far from the Chichester border. (Courtesy of New Hampshire Historical Society.)

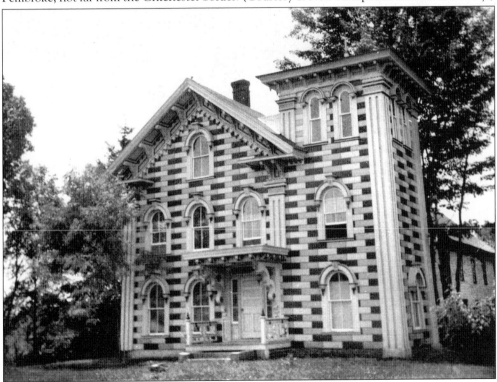

CAPT. WILLIAM FIFE HOUSE, 1915. Also known as the Gingerbread House, this distinctive residence, constructed about 1847, is on the corner of Pembroke Street and Bow Lane. (Courtesy of New Hampshire Historical Society.)

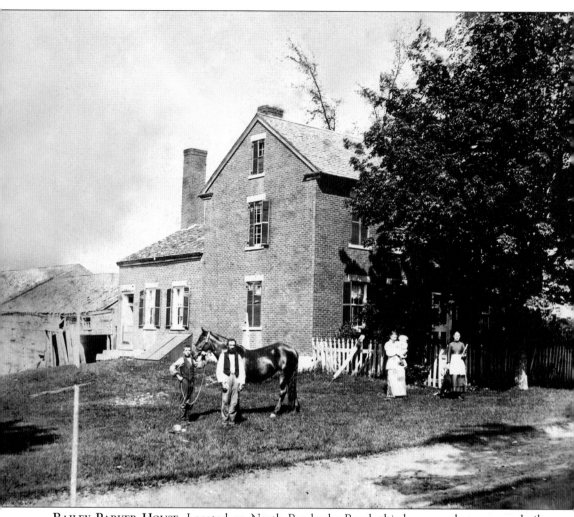

BAILEY PARKER HOUSE. Located on North Pembroke Road, this house and store were built about 1830. Since it was difficult and costly to transport bricks over long distances, the home's construction suggests that there may have been a small brickyard in this area of town as well. (Courtesy of Jim Garvin.)

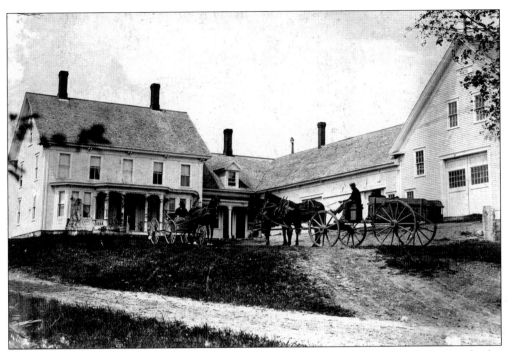

TRUEWORTHY FOWLER RESIDENCE. This farm was situated on North Pembroke Road, also known as Eighth Range Road. Trueworthy Fowler was very active in town affairs, serving at various times as selectman, moderator, and school committee member. He was also one of the researchers for the 1895 town history. (Courtesy of New Hampshire Historical Society.)

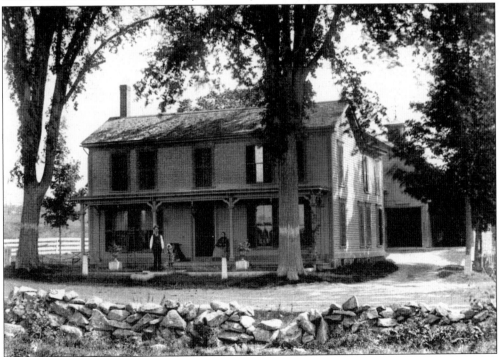

TURNPIKE STREET HOME. This house stands just below Main Street. (Courtesy of Brent Michiels.)

HOUSES ON KIMBALL STREET, 1907. Extending off into the background at right is Kimball Street, a road that runs roughly north to south and connects Main and Glass Streets. (Photograph by Wilkins; courtesy of Brent Michiels.)

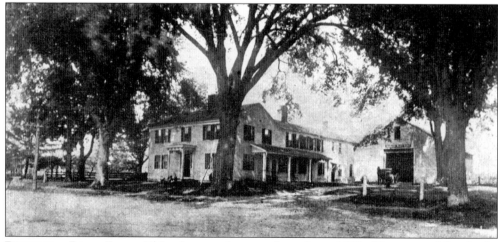

BERKSHIRE PARK FARM. This photograph was taken about 1908. (Courtesy of Pembroke Historical Society.)

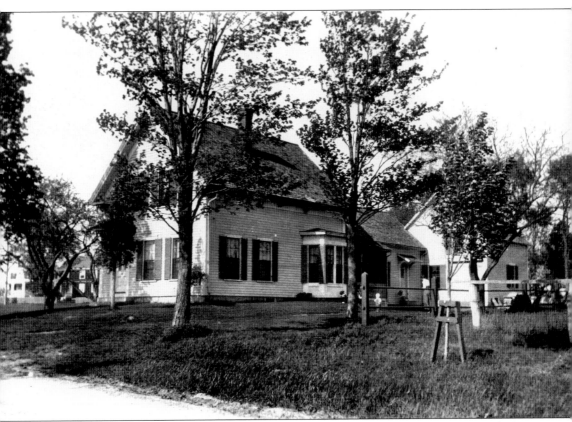

MILLS HOUSE, C. 1920. Situated at the top of Broadway hill and adjacent to Pembroke Park, this house was owned by the Mills sisters in the 1890s. Clinton and Rebecca Hanson have owned the home since 1984. (Courtesy of Clinton and Rebecca Hanson.)

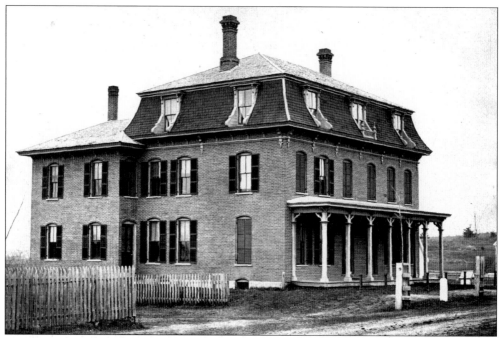

PIPER HOUSE. Constructed by William H. Piper in the 1870s, this two-family house is on the corner of Broadway and Pleasant Street. Piper was a merchant in town from 1868 to 1879, and he also built one of the commercial buildings on Main Street. (Courtesy of Pembroke Historical Society.)

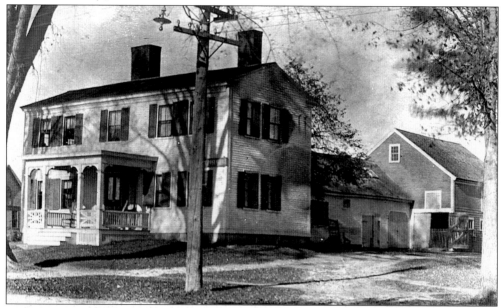

POST OFFICE, C. 1900. The post office in Pembroke has been relocated quite a bit over its history. From 1885 until at least 1895, the post office occupied a building on Pembroke Street, diagonally across from the town hall. The structure seen here is also on Pembroke Street, at the corner of Church Road. The postmistress by 1900 was Mary Adams, and Smith N. Ellsworth took over as postmaster after 1904. (Courtesy of Pembroke Historical Society.)

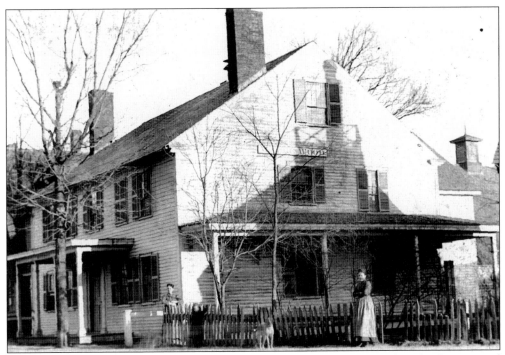

MAPLEWOOD, 1849 (ABOVE) AND C. 1870 (BELOW). This Main Street boardinghouse stood facing up Broadway on a site now occupied by the Petit Funeral Home. Jeremiah Hall Wilkins constructed this house in the 1820s or 1830s. The building was replaced by the Chickering House (see page 61) in the mid-1890s. (Courtesy of Pembroke Town Library.)

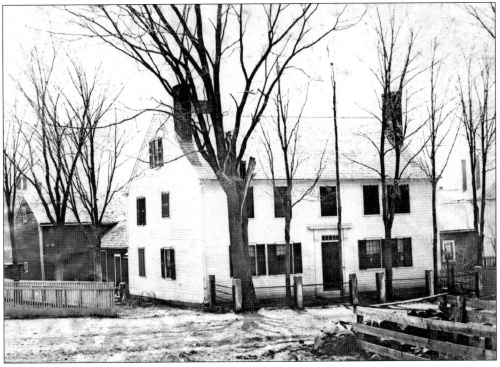

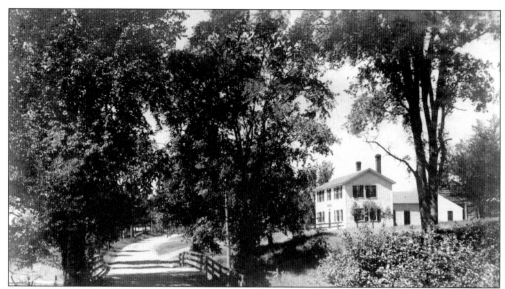

BROWN PLACE, 1910. This farm is located on Buck Street near Hampshire Brook. (Courtesy of Don Carrier.)

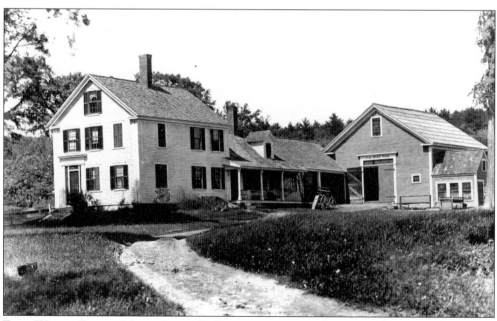

ELM WOOD FARM. Many "named" houses in town often served as guesthouses or boardinghouses. (Courtesy of Pembroke Historical Society.)

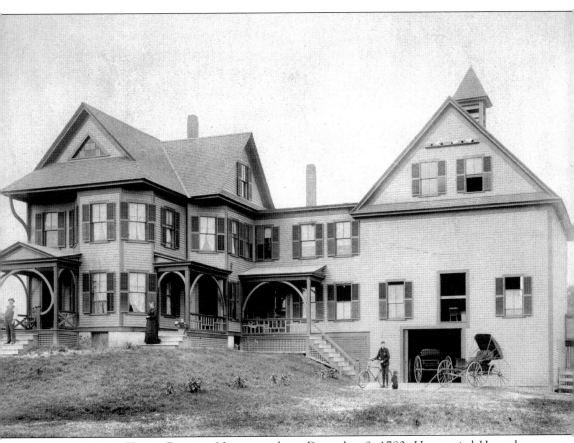

BENNING NOYES HOME. Benning Noyes was born December 9, 1780. He married Hannah Story in 1800 and they had four children. Noyes passed away in November 1814 in Bow, New Hampshire. (Courtesy of New Hampshire Historical Society.)

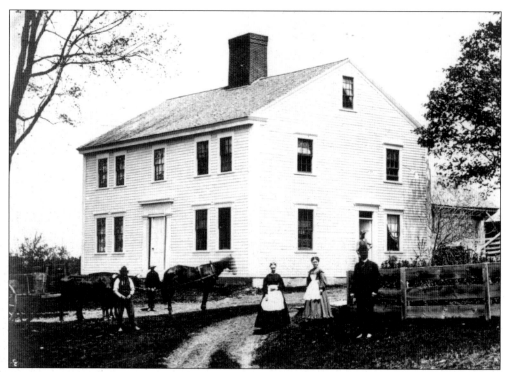

CHICKERING HOMESTEAD. This house, which stood on Pembroke Street just south of what is now Route 106, was built in 1804 by Deacon John Chickering. (Courtesy of Pembroke Historical Society.)

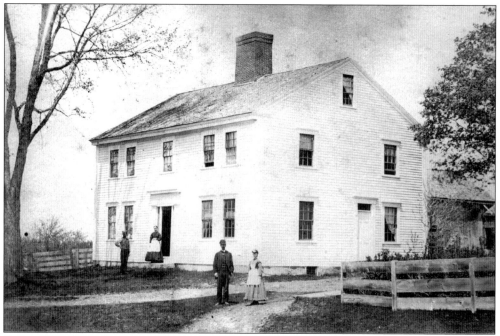

CHICKERING HOMESTEAD. Jabez and Sue Chickering are pictured here in front of their home. This building was destroyed by fire in 1930 or 1931. (Courtesy of Pembroke Historical Society.)

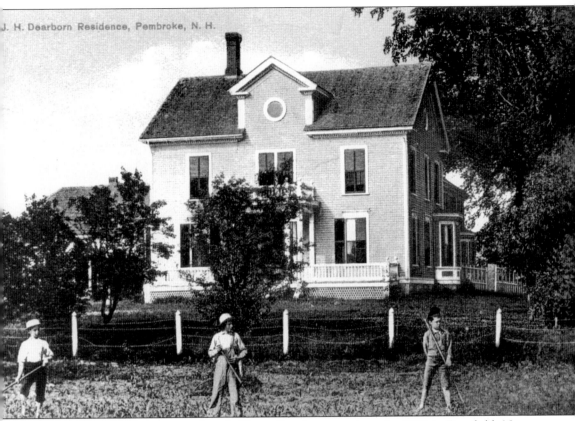

J. H. DEARBORN RESIDENCE. Joseph Henry Dearborn was born in 1849 in Deerfield, New Hampshire. He attended Pembroke Academy and graduated from Harvard in 1871. Nine years later, he married Sarah Stevens of Manchester. Dearborn served as a selectman and was a member of the Pembroke Town History Company, which produced the town's 1895 history. This house was located on Dearborn Road. (Courtesy of Pembroke Town Library.)

WALLACE FARM. This brick house on Pembroke Street stands on the site of a 1770s tavern. It now houses the offices of Historic Properties Realtors. The original house on this property was built in 1732 by Timothy Knox. (Courtesy of Pembroke Historical Society.)

Four
BUSINESS AND INDUSTRY

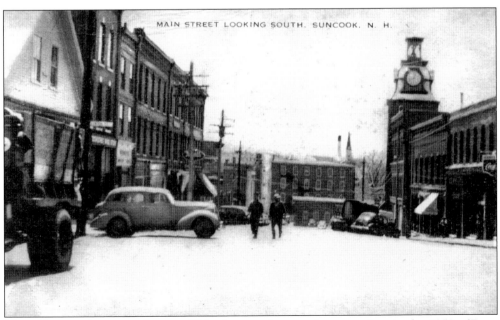

MAIN STREET, LOOKING SOUTH. This photograph was taken sometime in the 1950s. (From the collection of the author.)

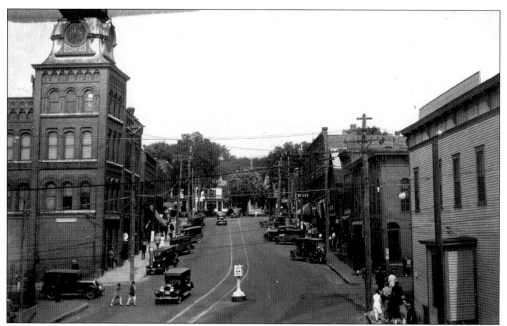

MAIN STREET, 1940S. This is a view of Main Street from the Suncook River, facing northeast. (Courtesy of Pembroke Town Library.)

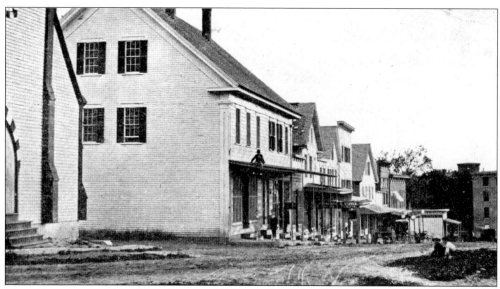

MAIN STREET, C. 1867. This photograph depicts the east side of Main Street. On the far left is a corner of the Baptist church, which burned down in 1878. Webster Mill can be seen in the background on the right. (Courtesy of Pembroke Town Library.)

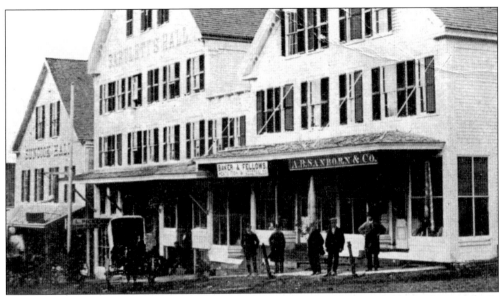

MAIN STREET, 1867. Seen here is the west side of Main Street. These buildings burned down in 1876. (Courtesy of Pembroke Town Library.)

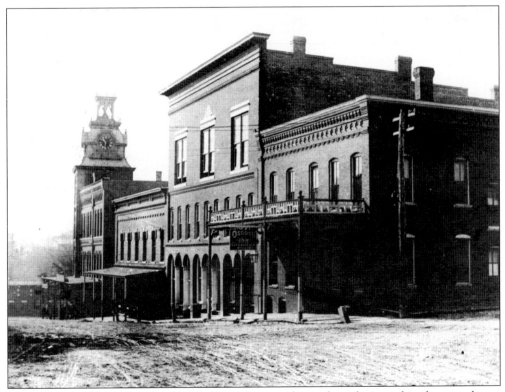

MAIN STREET. The west side of Main Street has not changed much since this photograph was taken around 1890. (Courtesy of Pembroke Historical Society.)

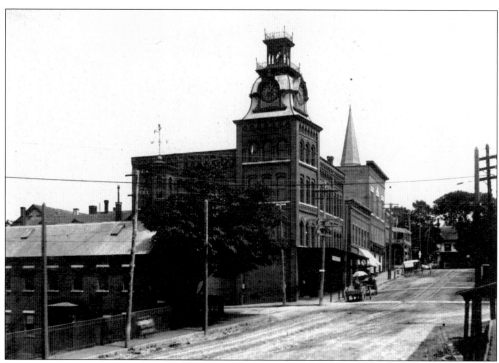

MAIN STREET. This is a view of the west side of the street, facing north. (Courtesy of Pembroke Historical Society.)

SHOPS ON MAIN STREET. This photograph dates from the 1930s. (Courtesy of Pembroke Historical Society.)

BARTLETT'S OPERA HOUSE AND HOTEL, MAIN STREET. Many buildings along Main Street were the victims of several devastating fires in 1876, 1878, and 1886. The structures pictured here were erected after the 1886 fire; they were designed and built by Samuel S. Ordway. (Courtesy of Pembroke Town Library.)

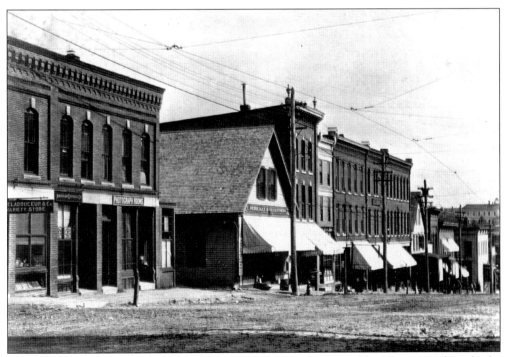

MAIN STREET. The east side of Main Street is seen here in the 1920s. (Courtesy of Pembroke Historical Society.)

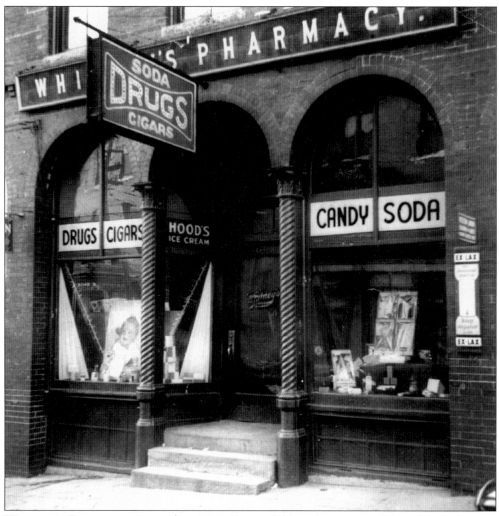

WHITNEY'S PHARMACY. Located on Main Street, Whitney's was one of the village's thriving businesses. (Courtesy of Pembroke Town Library.)

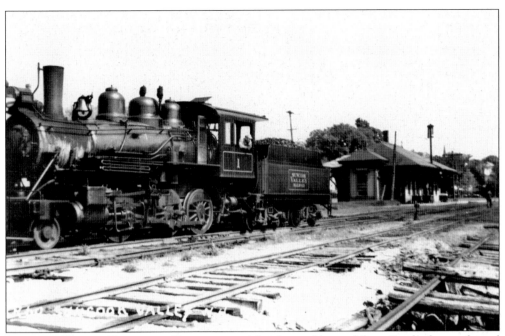

SUNCOOK VALLEY RAILROAD. Passengers and freight could travel from Pembroke northward to Concord or the White Mountains, eastward to Portsmouth, and southward to Boston. Completed in 1869, the Suncook Valley Railroad was operated by the Boston and Maine Railroad until 1924, and then operated independently until the early 1950s. (From the collection of the author.)

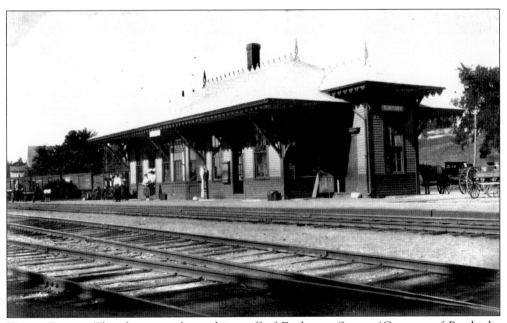

TRAIN DEPOT. This depot was located just off of Exchange Street. (Courtesy of Pembroke Historical Society.)

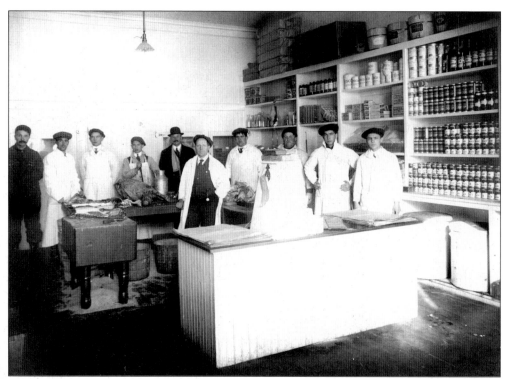

SIMPSON MILLER STORE. Stores such as this were an important part of village life. Residents could get local news along with their groceries. This Main Street shop was in operation from 1890 until sometime after 1895. (Courtesy of Pembroke Historical Society.)

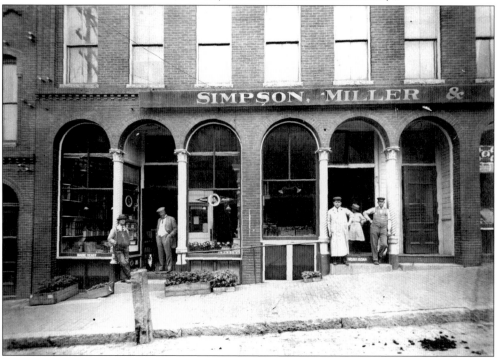

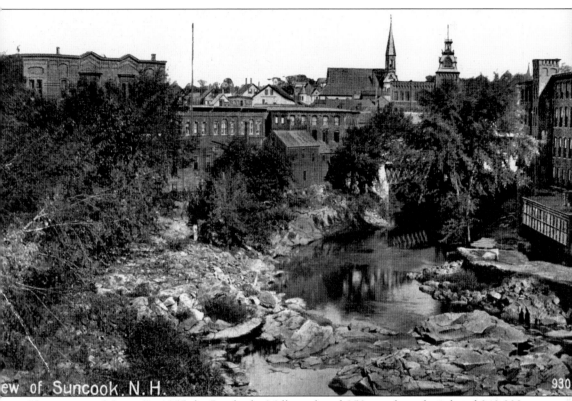

ew of Suncook, N.H. 930

VIEW OF THE MILLS. By 1855 the Pembroke Mill employed 250 people and produced 240,000 yards of cloth annually. (Courtesy of Pembroke Historical Society.)

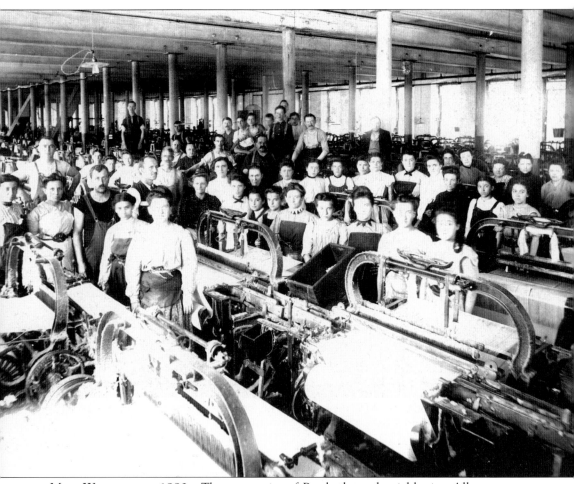

MILL WORKERS, C. 1880S. The economies of Pembroke and neighboring Allenstown were dependent on the mills that produced goods such as cotton cloth. The mill workers were mostly French Canadian immigrants. (Courtesy of Pembroke Historical Society.)

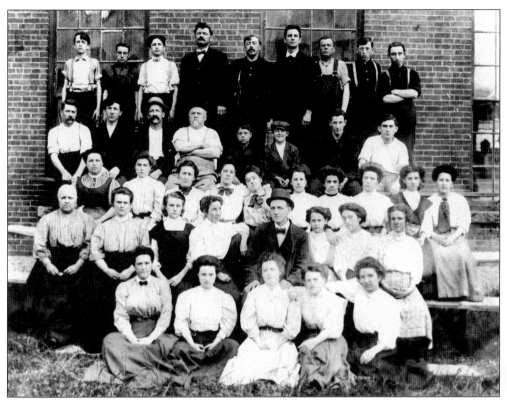

MILL EMPLOYEES, c. 1910. By 1900, the mills in Pembroke employed more than 1,500 workers. (Courtesy of Regis Lemaire.)

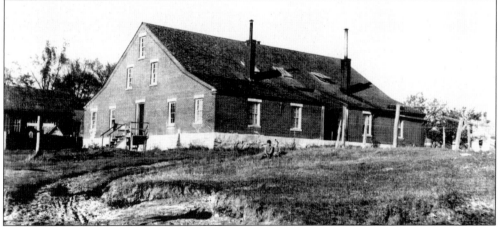

SUNCOOK GLASSWORKS. In 1839 the Chelmsford Glass Company relocated its glass factory to Pembroke village, near the site of the present-day post office. This factory produced window glass, bowls, pitchers, and other tableware with a distinctive greenish color. Unfortunately, suitable sand in large amounts proved to be unavailable locally, so sand had to be transported from New Jersey. These costs, combined with low tariffs on imports of European glass in the 1840s, made glass manufacture in Pembroke an unprofitable undertaking. The factory was closed in 1850. The building was subsequently converted into apartments for local mill workers. It was torn down in 1917. (Courtesy of Pembroke Historical Society.)

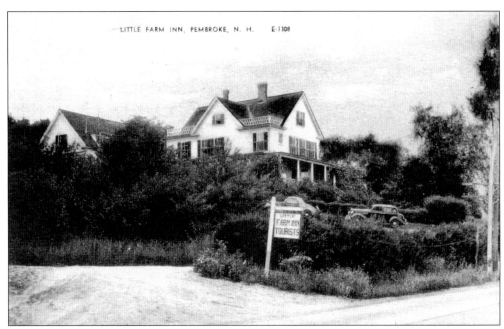

LITTLE FARM INN. The main road between Manchester and Concord was built right through Pembroke. As a result, taverns, inns, and restaurants such as this sprung up along Pembroke Street. (Courtesy of Don Carrier.)

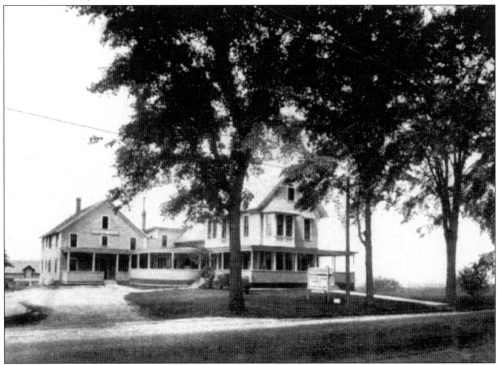

PLEASANT VIEW INN. Owned by J. W. and E. E. Williamson, the Pleasant View Inn provided meals and a place to stay for travelers. Its location on Pembroke Street made it convenient for those traveling between Manchester and Concord. (Courtesy of Don Carrier.)

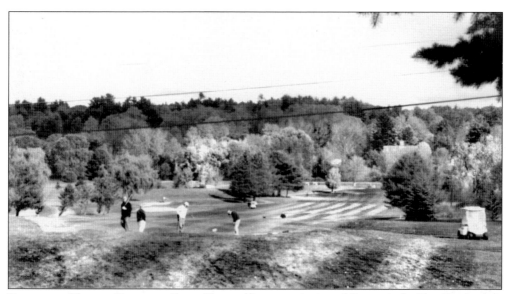

PLAUSAWA VALLEY COUNTRY CLUB. Here golfers are enjoying a fall round of golf on Pembroke's golf course, which was started in 1963. Originally a 9-hole course, it was expanded to 18 holes in 1989. Plausawa was the name of a Native American who camped in the area at the time of Pembroke's settlement. A large hill in the northeast part of town is also named for him. (Top photograph by the author; bottom photograph courtesy of Plausawa Valley Country Club.)

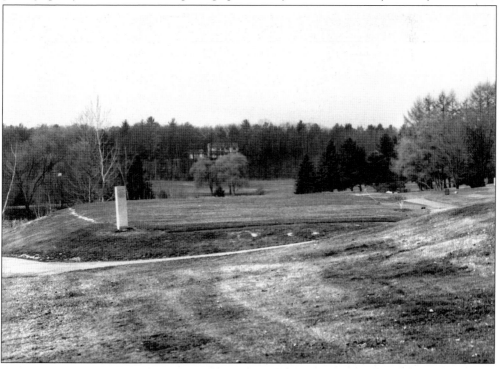

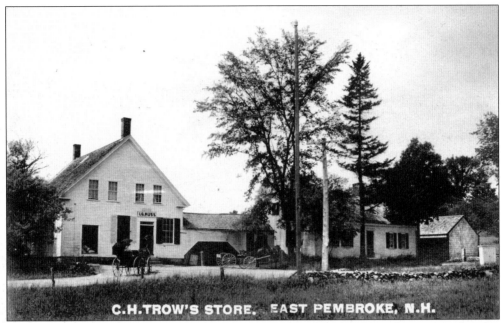

J. T. Trow's Store, after 1904. Located in East Pembroke near the Buck Street Bridge, this store was built by Josiah B. and Joseph C. Cram in 1852. Isaac G. Russ bought the store in 1864 and ran it until at least 1904. The name of the owner was misprinted on this postcard. (Courtesy of Don Carrier.)

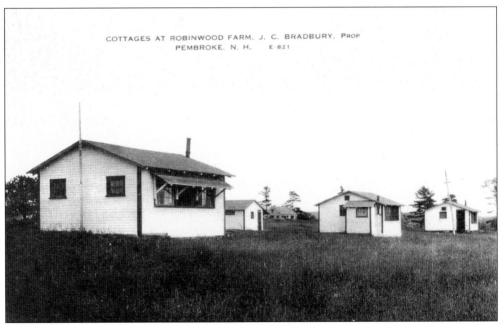

Cottages at Robinwood Farm, c. 1910. J. C. Bradbury owned these guest cottages on Pembroke Street. (Courtesy of Don Carrier.)

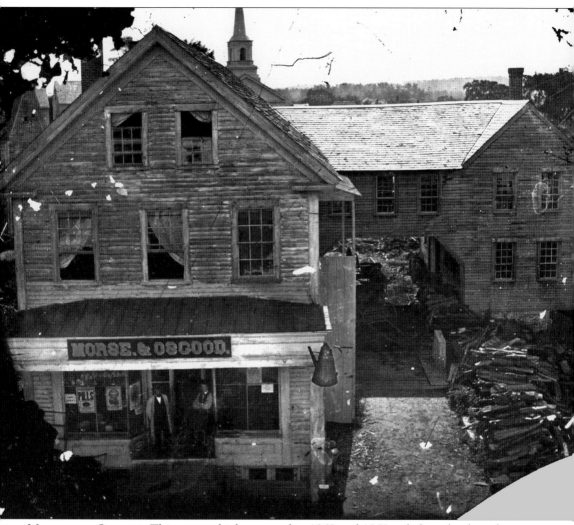

MORSE AND OSGOOD. This store, which operated in 1862 and 1863, is believed to have been located in the village near the present-day Rainville Shoes on Main Street. (Courtesy of Brent Michiels.)

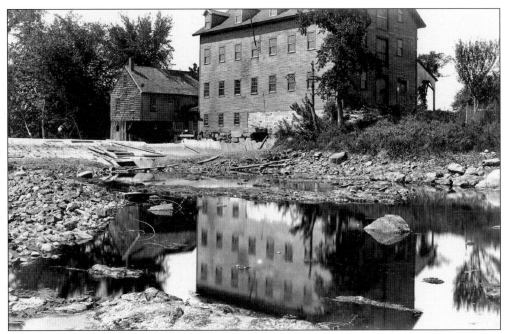

MILL WITH POND. Industry in Pembroke was concentrated in three main neighborhoods: the village along the Suncook River; the East Pembroke/Buck Street area further along the Suncook; and the vicinity of North Pembroke on the Soucook River. The mill building pictured here was likely in the North Pembroke area. (Courtesy of Brent Michiels.)

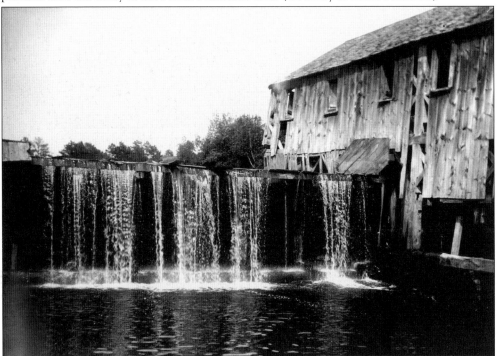

RICHARDSON'S MILL. This sawmill was on the Soucook River in the northernmost part of town, near the Chichester border. (Courtesy of New Hampshire Historical Society.)

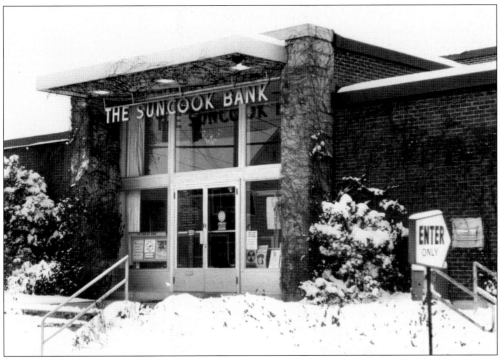

SUNCOOK BANK. Currently a branch of the Bank of New Hampshire, the Suncook Bank opened its doors in September 1916. (Photograph by Brent Michiels.)

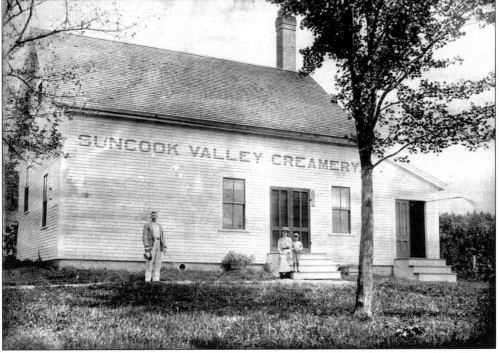

SUNCOOK VALLEY CREAMERY, C. 1899. This cottage business was located on Glass Street. (Courtesy of New Hampshire Historical Society.)

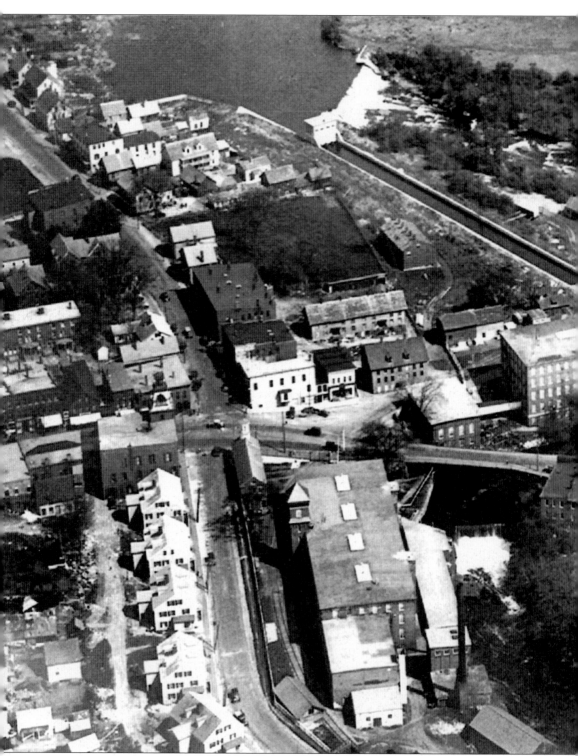

AERIAL VIEW. The Suncook River (in the middle foreground) separates Pembroke (left) from Allenstown (right). These two towns are often collectively referred to as Suncook. Note the

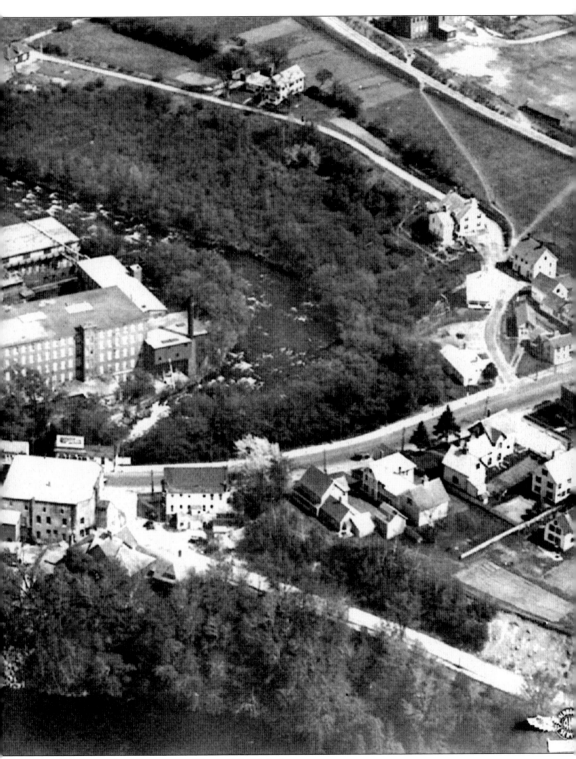

canal for the mills. (Courtesy of Brent Michiels.)

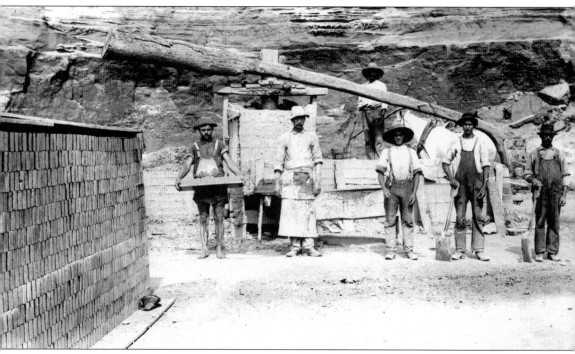

GEORGE SIMPSON'S BRICKYARD, C. 1900. The manufacturing of bricks was an important Pembroke industry. Clay near the rivers was formed into bricks using wooden molds (seen here held by the man on the left), dried, and then fired in kilns at a temperature around 1,800 degrees Fahrenheit. (Courtesy of New Hampshire Historical Society.)

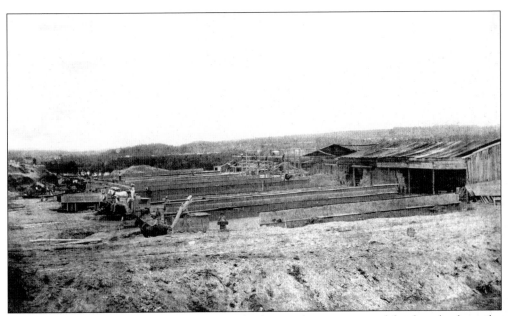

WHITTEMORE'S BRICKYARD, C. 1873. Pembroke was home to several brickyards along the Merrimack River. It is estimated that those brickyards by 1832 supplied approximately 1.2 million bricks per year to the area. (Courtesy of New Hampshire Historical Society.)

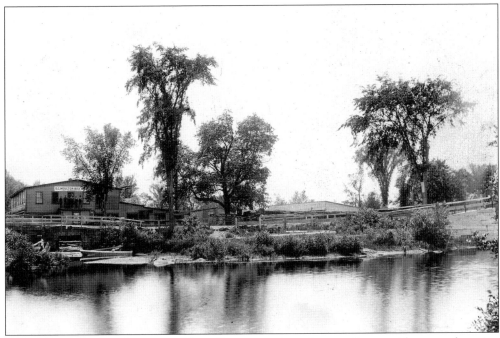

R. C. MOULTON BOX COMPANY. The village is not the only area of town with a manufacturing history. This box manufacturer was located in East Pembroke. (Courtesy of New Hampshire Historical Society.)

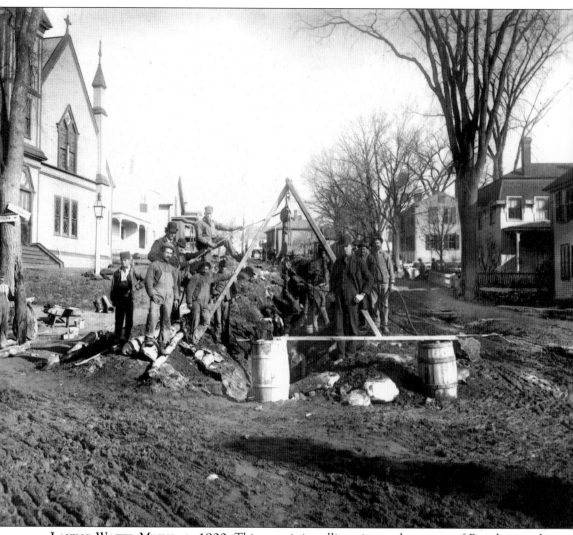

LAYING WATER MAINS, C. 1900. This crew is installing pipe at the corner of Broadway and Main Street. Gedeon Petit Sr. is the first man standing outside of the ditch on the right. Unfortunately, all the others are unidentified. (Courtesy of Brent Michiels.)

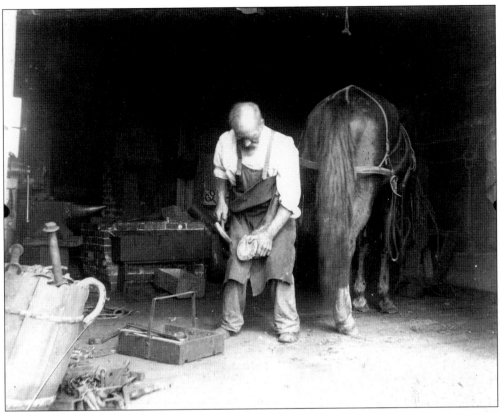

GEORGE P. CASS, BLACKSMITH. Built about 1808, this blacksmith shop was located near the Buck Street Bridge in East Pembroke. (Courtesy of New Hampshire Historical Society.)

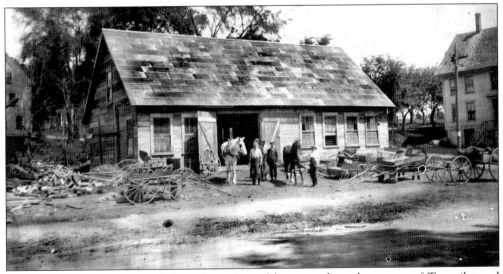

BLACKSMITH SHOP, C. 1920. The shop pictured here stood on the corner of Turnpike and Glass Streets. (Courtesy of Brent Michiels.)

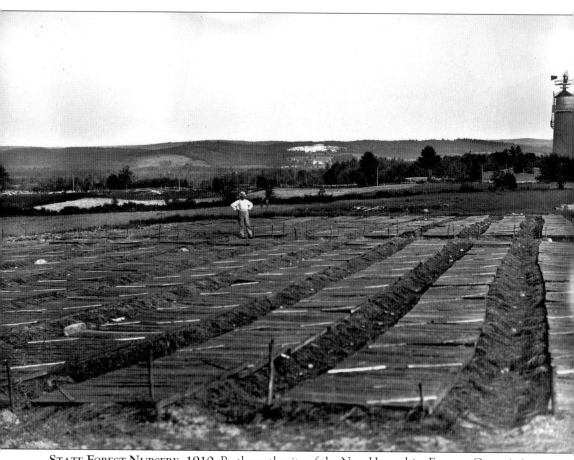

STATE FOREST NURSERY, 1910. By the authority of the New Hampshire Forestry Commission, the State Forest Nursery was established on a small piece of land in Pembroke. The nursery's purpose was to provide native seedlings to those areas in need of reforestation. In its first year, the nursery sold 50,000 seedlings, although the demand was almost four times that amount. In 1911, the state nursery operations were moved to Boscawen. (Courtesy of New Hampshire Division of Forests and Lands.)

CORPORATION BLOCK. This structure was built by Addison N. Osgood and stood where the municipal parking lot on Crescent Street is currently located. (Courtesy of Dr. Vincent Greco.)

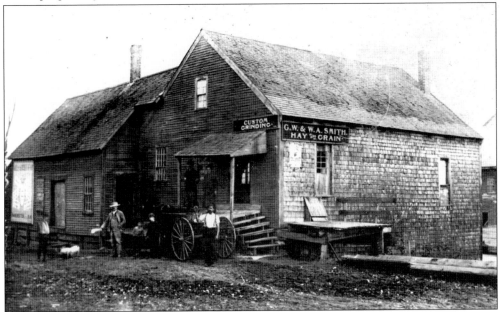

G. W. & W. A. SMITH HAY AND GRAIN. Like most of New England, farming was an important part of Pembroke life. Many farms operated along Pembroke Street, but the Buck Street area was also a prime agricultural territory, which produced hay, grain, milk, and cider, among other crops. (Courtesy of Pembroke Town Library.)

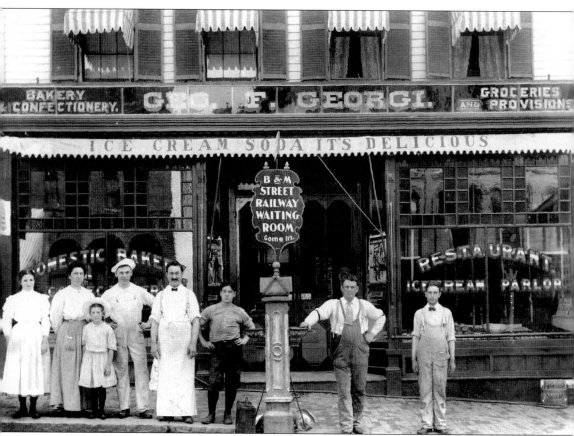

GEORGI'S BAKERY AND STORE. This Main Street establishment was one of many thriving stores in the village area. George Georgi also ran a restaurant to the right of the store. (Courtesy of Dr. Vincent Greco.)

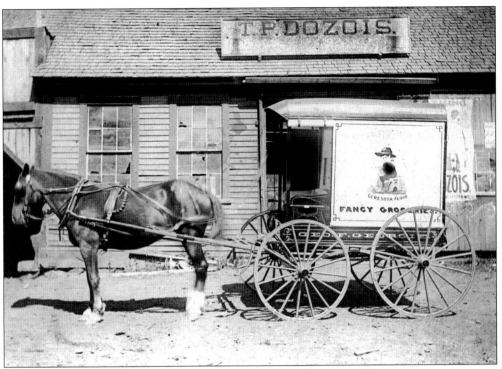

GEORGI'S DELIVERY WAGON. This wagon was used to deliver goods from Georgi's store to outlying areas of town. (Courtesy of Dr. Vincent Greco.)

GEORGI'S STORE, 1888. George Georgi's first store was located on Glass Street. The business was relocated to Main Street a year later. (Courtesy of Dr. Vincent Greco.)

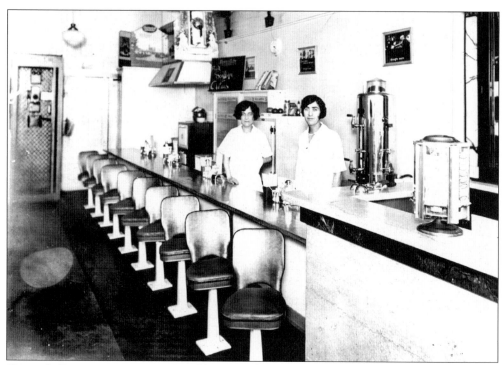

GEORGI'S RESTAURANT, 1941. In addition to the store and bakery, George Georgi operated a restaurant. Pictured here are Josie LaPage (left) and Emma Brien. (Courtesy of Dr. Vincent Greco.)

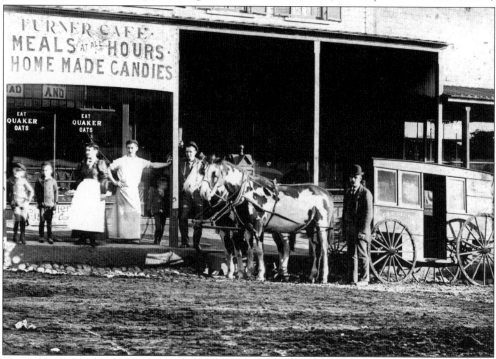

MAIN STREET. This picture was taken around 1880. (Photograph by J. Wilkins; courtesy of Dr. Vincent Greco.)

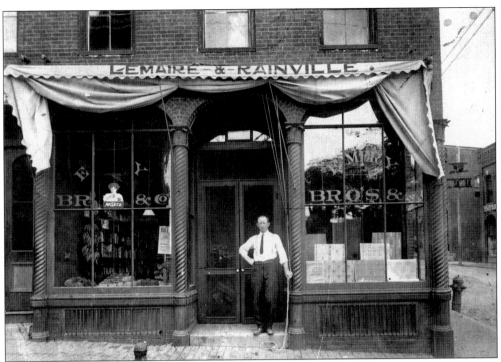

LEMAIRE AND RAINVILLE STORE, C. 1913. John B. Regis Lemaire opened this store in the village on March 7, 1912, and was in business for 45 years. (Courtesy of Regis Lemaire.)

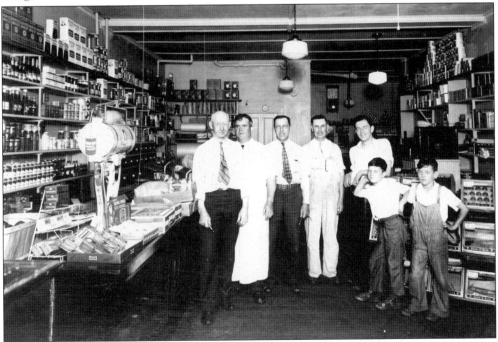

LEMAIRE AND RAINVILLE STORE. Pictured inside the store are, from left to right, John Lemaire, Hermas Daviaut Sr., Eviene Rainville, ? Canseler, Joe Rainville, unidentified, and Minot Raymond. (Courtesy of Regis Lemaire.)

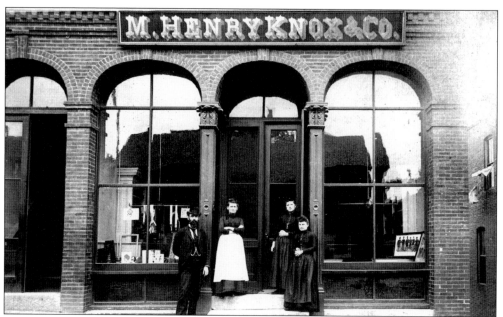

M. HENRY KNOX AND COMPANY. This store, one of many in the village, was located on Glass Street. This photograph was taken in October 1890. (Courtesy of Dr. Vincent Greco.)

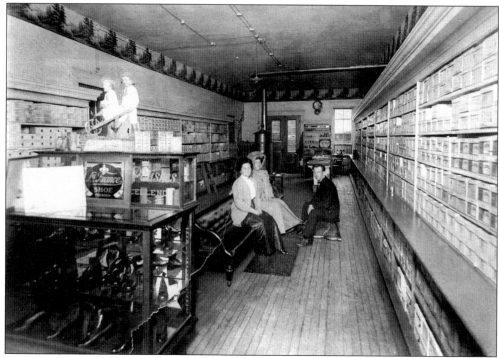

RAINVILLE'S SHOE STORE. Rainville's Shoes on Main Street is the oldest continuously operating business in Suncook village. (Courtesy of Dr. Vincent Greco.)

Five

INSTITUTIONS

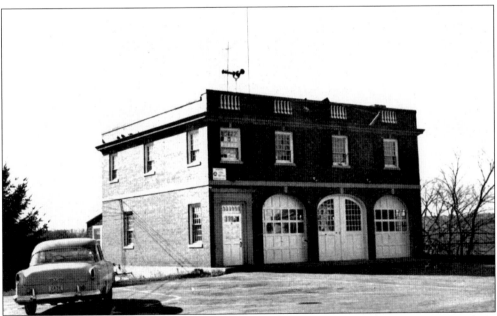

FIREHOUSE, C. 1950S. Located on Union Street, this firehouse was used from 1930 until 1976, when the present firehouse was built on Pembroke Street. The police department used this building until April 2004. (Courtesy of Brent Michiels.)

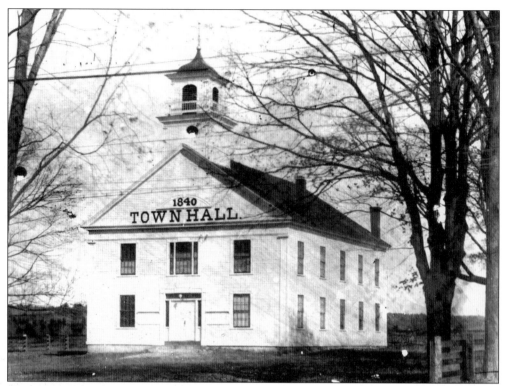

TOWN HALL. Built in 1840 as the Peoples Literary Institute and Gymnasium (an early rival school to Pembroke Academy), this building was purchased by the town in 1865 for $1,200. It was renovated and used as the town hall until it was destroyed by fire in 1965. (Photograph by Brent Michiels.)

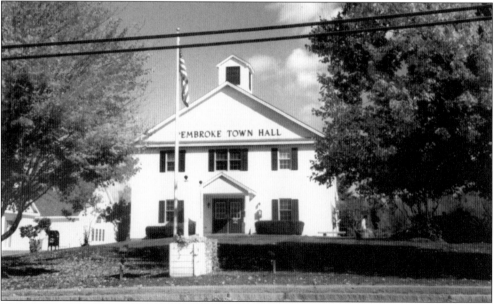

TOWN HALL. Built in 1988 on the site of the previous town hall that was destroyed by fire, this building is architecturally very similar to its predecessor. (Photograph by the author.)

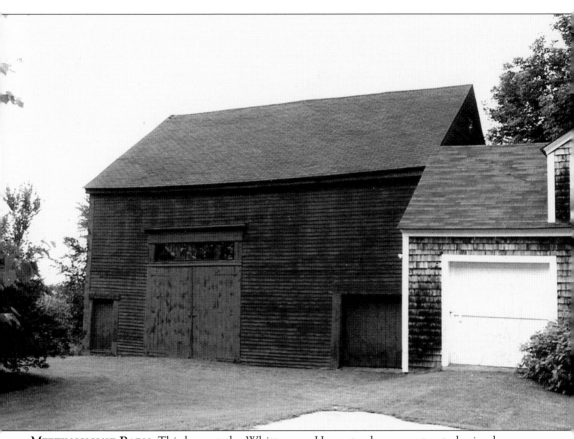

MEETINGHOUSE BARN. This barn at the Whittemore Homestead was constructed using beams from the town's first meetinghouse, which was built in 1733. (Courtesy of Bert Whittemore.)

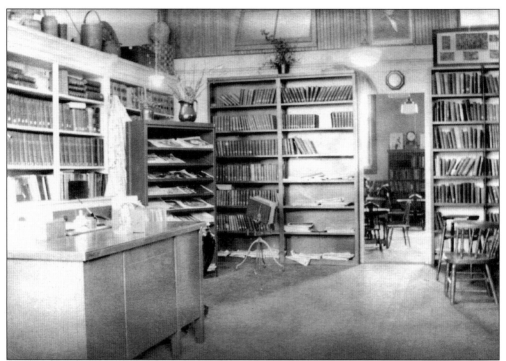

PEMBROKE TOWN LIBRARY INTERIOR, 1913. Located in Baker's Block on Glass Street, this was the first incarnation of the town library. The library was later moved to a Main Street site between the Masonic Hall and Whitney's Pharmacy. When the library was founded in 1897, it owned 426 books; by 1923 the collection had grown to 3,470 volumes. A lack of space and high rental costs forced the library's relocation to the Iverson House on Pembroke Street in 1981. (Courtesy of Pembroke Town Library.)

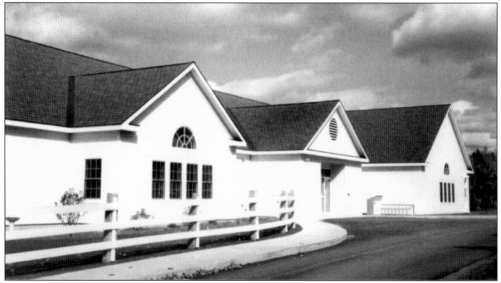

PEMBROKE TOWN LIBRARY. Dedicated in June 2003, this building is the first library building to be owned by the town. The library previously occupied the Iverson House on Pembroke Street, which currently houses the sewer department. (Photograph by the author.)

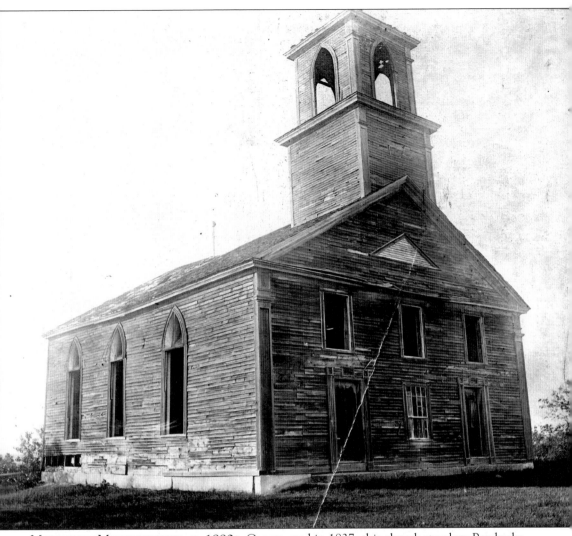

Methodist Meetinghouse, c. 1880s. Constructed in 1837, this church stood on Pembroke Hill. It was torn down sometime after 1895. (Courtesy of Pembroke Town Library.)

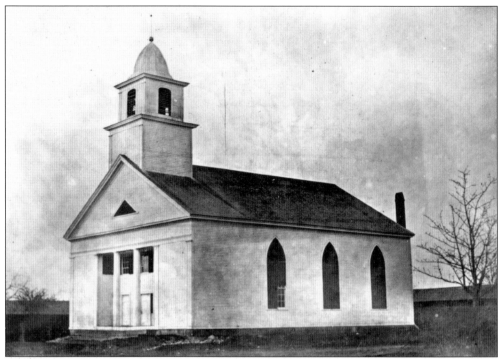

CONGREGATIONAL CHURCH, 1860s. This church on Pembroke Street is the oldest in town that is still in use today (with some additions). It was built in 1836. (Courtesy of Brent Michiels.)

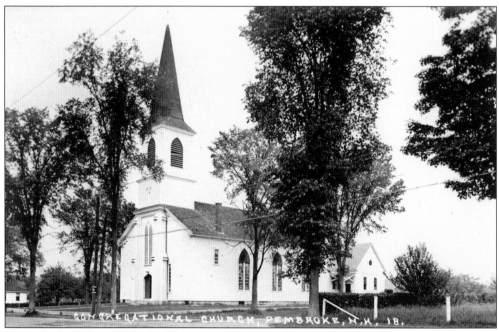

CONGREGATIONAL CHURCH. This is a view of the church after the addition of the steeple in 1871. (Courtesy of New Hampshire Historical Society.)

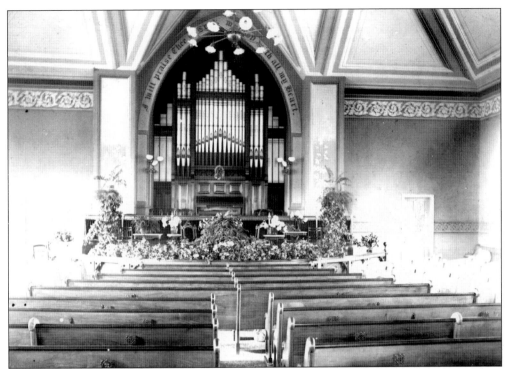

METHODIST CHURCH. This undated photograph shows the interior of the Methodist church located on the corner of Union and Main Streets. (Courtesy of Brent Michiels.)

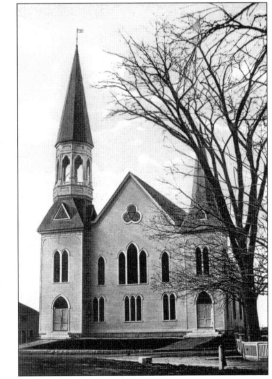

METHODIST CHURCH. This church was built in 1884, after the previous Methodist church on Church Street was destroyed by fire in 1882. On February 15, 1911, this structure also burned down, but it was quickly replaced in 1912 by the church that stands in the village today. (Courtesy of Pembroke Town Library.)

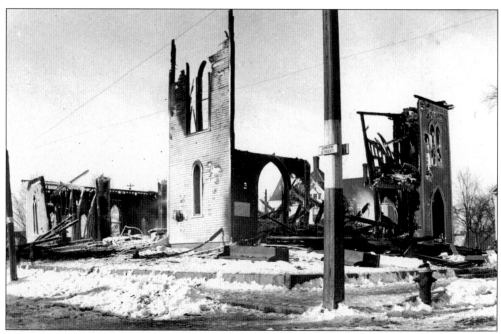

METHODIST CHURCH, FIRE AFTERMATH. These are the ruins of the Methodist church after the fire of February 15, 1911. (Courtesy of Dr. Vincent Greco.)

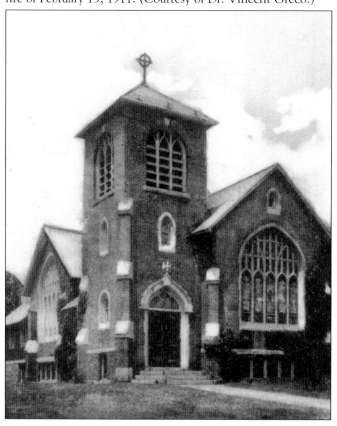

METHODIST CHURCH. It is unclear when the tower of this church was renovated to look like it does today. (Courtesy of Brent Michiels.)

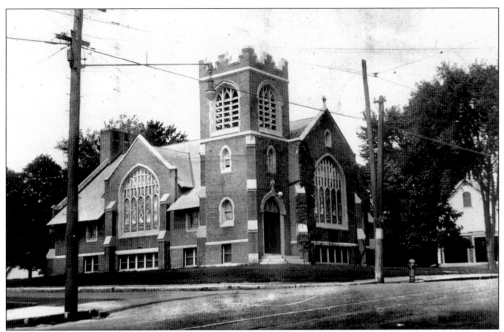

METHODIST CHURCH. A familiar landmark in the village, this Methodist church was constructed between 1911 and 1912. (Courtesy of Pembroke Town Library.)

BAPTIST CHURCH. Situated on the corner of Broadway and Main Street, this church was built in 1879, after the previous church in the village was destroyed by fire. This building was taken down in 1941, and the site is now a small park dedicated to George Lamiette, a Pembroke resident who died in the USS *Maine* disaster in 1898. (Courtesy of Pembroke Town Library.)

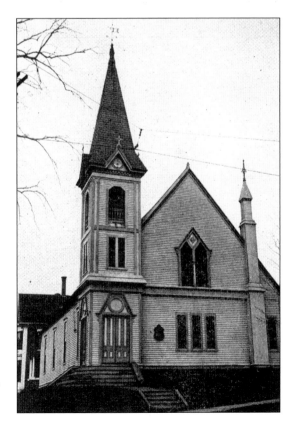

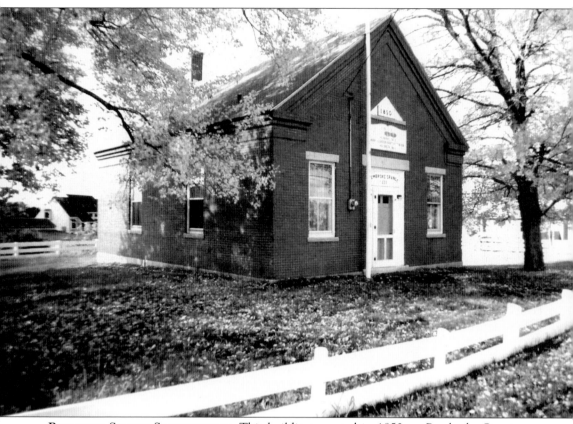

PEMBROKE STREET SCHOOLHOUSE. This building, erected in 1850 on Pembroke Street, was used as a school for grades one through six until 1946. It is currently used as the Grange and Odd Fellows Hall. (Courtesy of Marilyn Ross.)

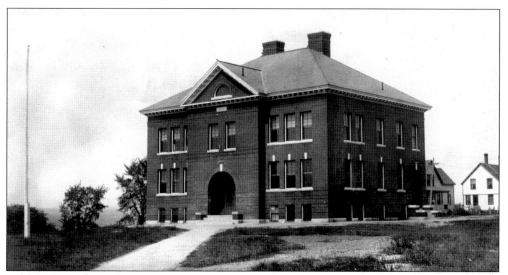

ELEMENTARY SCHOOL. Located on High Street, this school was constructed in 1907. It is still being used (with some additions) for kindergarten and first-grade classes. (Courtesy of Pembroke Town Library.)

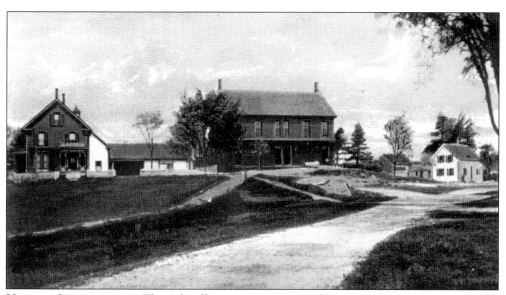

VILLAGE SCHOOLHOUSE. This schoolhouse was constructed in 1872 on Main Street, near the intersection with Pembroke Street. The building was used as a gymnasium after 1908, when the High Street School was built. It has been the property of the Pembroke Water Works since 1951. (Courtesy of Don Carrier.)

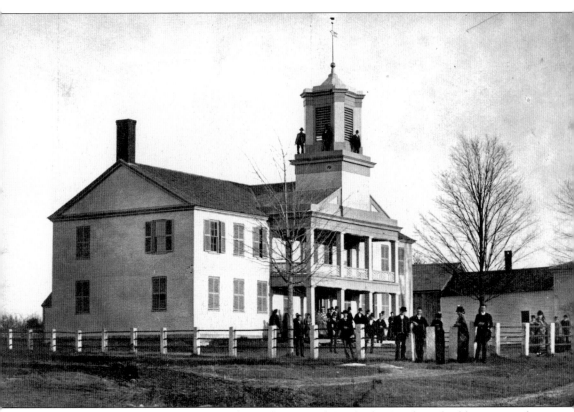

PEMBROKE ACADEMY, C. 1880S. This is the original Pembroke Academy building, erected in 1818. The academy opened in May of that year with 48 pupils. Early on, it was sometimes referred to as Blanchard Academy, after Dr. Abel Blanchard, the school's first donor. This building was destroyed by fire on June 21, 1900. (Courtesy of the Pembroke Town Library.)

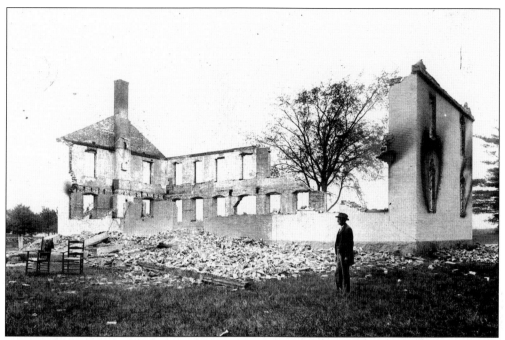

FIRE AFTERMATH, PEMBROKE ACADEMY. On June 21, 1900, the academy building burned down. A brick building replaced it on the site in 1904. Here, academy principal Isaac Walker inspects the damage. (Courtesy of Pembroke Historical Society.)

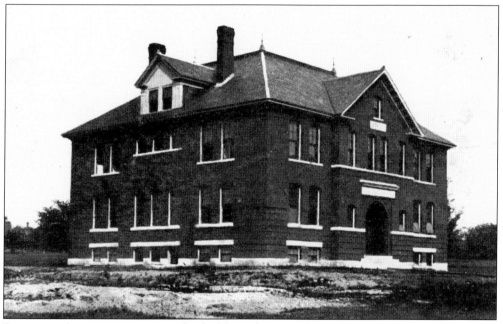

PEMBROKE ACADEMY, C. 1910. This building, the second incarnation of Pembroke Academy, was constructed in 1904 after a fire destroyed the previous building in 1900. In November 1936, this structure also burned down. (Courtesy of Pembroke Town Library.)

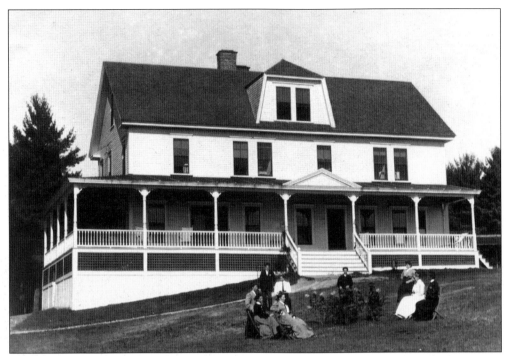

PEMBROKE SANITARIUM. This tuberculosis hospital was situated up on Pembroke Hill. One of the hospital buildings had tiers of sleeping porches to allow the residents to sleep in the fresh air. This structure would eventually become the Congregational Christian Conference Center. (Courtesy of Pembroke Historical Society.)

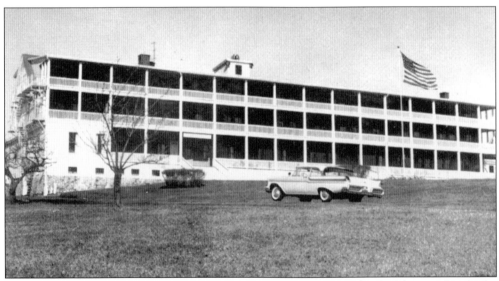

CONGREGATIONAL CHRISTIAN CONFERENCE BUILDING, 1960S. This building on Pembroke Hill was formerly a tuberculosis sanitarium. It was used as a retreat and conference center until 1978. (Courtesy of Brent Michiels.)

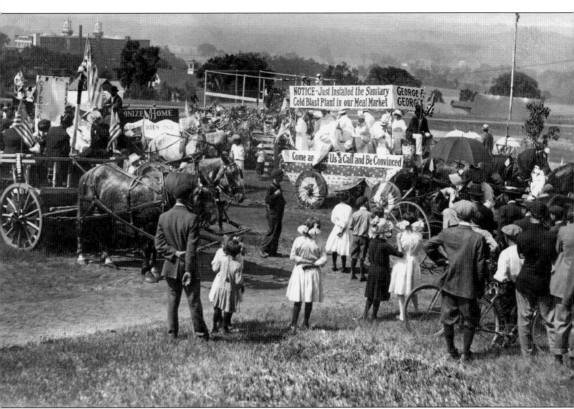

FOURTH OF JULY CELEBRATION, 1913. Like the rest of the country, Pembroke celebrated Independence Day with a parade, games, and fireworks. (Courtesy of Dr. Vincent Greco.)

RELOCATION OF HISTORICAL SOCIETY BUILDING, 1997. The historical society building was originally constructed in 1808 as the District 10 schoolhouse. It was used as a school until 1943, when it became the headquarters of the Buck Street Fidelity Club. The structure was deeded to the town in 1994, and the town in turn deeded the building to the historical society in 1996. The building was moved from its Buck Street location to its current home behind the town hall in December 1997. (Photograph by Sylwia Kapuscinski; courtesy of the *Concord Monitor*.)

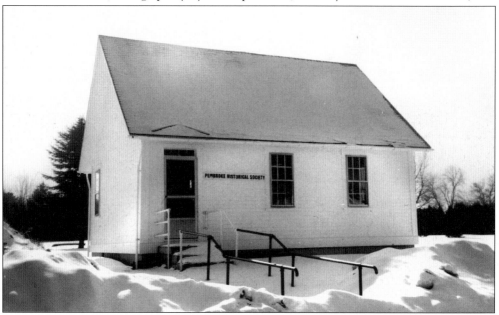

PEMBROKE HISTORICAL SOCIETY. This building contains many records and artifacts related to the history of Pembroke. (Photograph by the author.)

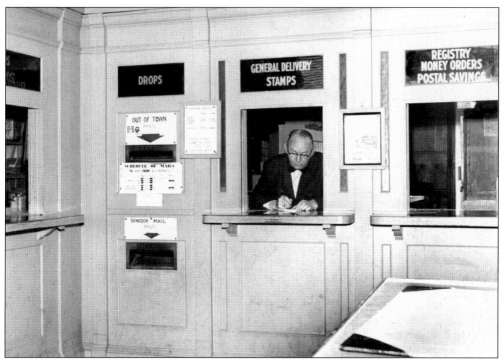

POST OFFICE. This interior view of the Main Street Post Office was taken in 1959. (Courtesy of Regis Lemaire.)

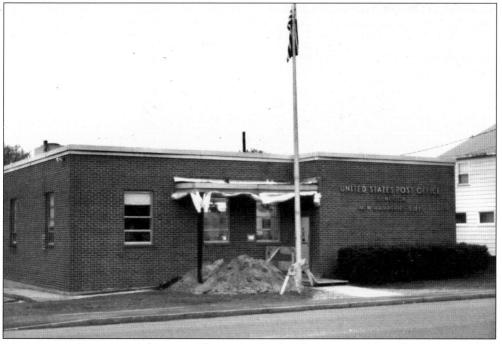

POST OFFICE BUILDING. This post office serves both Allenstown and Pembroke—under the name of Suncook—and is located on the Pembroke side of the village on Glass Street. This photograph was taken in May 1990. (Courtesy of Brent Michiels.)

BIBLIOGRAPHY

Atlas of New Hampshire. Boston: D. H. Hurd and Company, 1892.

Carter, Rev. N. F. and Hon. T. L. Fowler. *History of Pembroke, New Hampshire, 1730–1895*. 2 vols. Concord, NH: Republican Press Association, 1895. Reprinted, Allenstown-Pembroke Bicentennial Committee, 1976.

Charlton, Edwin A. *New Hampshire As It Is*. Claremont, NH: Tracy and Sanford, 1855.

Du Mont, John S. "The Fife Revolver." *The American Rifleman* 103 (September 1955): 22–23.

Hamilton, Charles et al. *A Short History of Pembroke, N.H.* Unpublished typescript. Pembroke Historical Society, 1992.

Keeler, Rev. S. C. *The Murdered Maiden Student: A Tribute to the Memory of Miss Josie A. Langmaid*. New York: Crum and Ringler, 1878.

Mann, Jennifer K. *Building Pembroke: The Evolution of a Landscape*. N.p.: [Old Suncook Vitalization Committee], 1985.

"Pembroke Academy: A Strong Factor in New Hampshire Educational Life." *Granite Monthly* XVI, no. 7 (July 1909): 225–238.

Pembroke Bicentennial Commemorative Booklet Committee. *The Town of Pembroke 1759–1959*. Concord, NH: Capital Offset, 1959.

Pembroke Steering Committee. "Historic and Cultural Resources." *Pembroke Master Plan: Steering Committee Final Draft*. April 19, 2004.

Wilson, Kenneth M. *New England Glass and Glassmaking*. New York: Thomas Y. Crowell Company, 1972.